THE BRICK BIBLE
PRESENTS
BRICK GENESIS

This is an original, modern interpretation of the Bible, based on older public domain translations such as the King James Bible, Darby's Bible, and Young's Literal Bible. In addition, modern English Bible translations were used as references, and the author consulted the original Hebrew for certain passages.

Skyhorse Publishing books may be purchased in bulk at special discounts for sales promotion, corporate gifts, fund-raising, or educational purposes. Special editions can also be created to specifications. For details, contact the Special Sales Department, Skyhorse Publishing, 307 West 36th Street, 11th Floor, New York, NY 10018 or info@skyhorsepublishing.com.

Skyhorse® and Skyhorse Publishing® are registered trademarks of Skyhorse Publishing, Inc.®, a Delaware corporation.

www.skyhorsepublishing.com

10 9 8 7 6 5 4 3 2 1

Library of Congress Cataloging-in-Publication Data is available on file.
Print ISBN: 978-1-62914-768-0
Ebook ISBN: 978-1-62914-886-1

Printed in China

Cover design by Brian Peterson
Cover photographs credit Brendan Powell Smith
Editors: Ann Treistman and Julie Matysik
Designer: Brian Peterson
Production managers: Abigail Gehring and Yvette Grant

IN THE BEGINNING, WHEN GOD CREATED
THE HEAVENS AND THE EARTH, THE EARTH WAS
FORMLESS AND EMPTY WITH DARKNESS COVERING
THE DEEP, AND THE SPIRIT OF GOD WAS HOVERING
OVER THE SURFACE OF THE WATERS

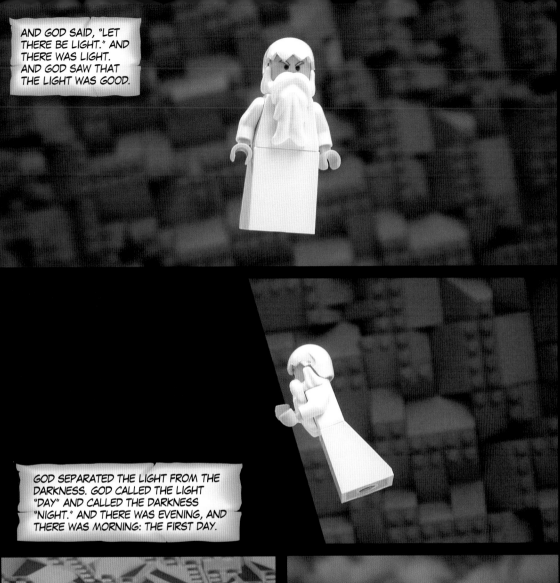

AND GOD SAID, "LET THERE BE LIGHT." AND THERE WAS LIGHT. AND GOD SAW THAT THE LIGHT WAS GOOD.

GOD SEPARATED THE LIGHT FROM THE DARKNESS. GOD CALLED THE LIGHT "DAY" AND CALLED THE DARKNESS "NIGHT." AND THERE WAS EVENING, AND THERE WAS MORNING: THE FIRST DAY.

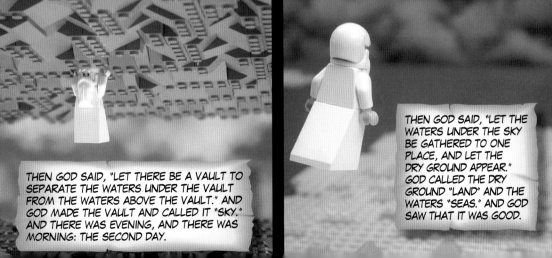

THEN GOD SAID, "LET THERE BE A VAULT TO SEPARATE THE WATERS UNDER THE VAULT FROM THE WATERS ABOVE THE VAULT." AND GOD MADE THE VAULT AND CALLED IT "SKY." AND THERE WAS EVENING, AND THERE WAS MORNING: THE SECOND DAY.

THEN GOD SAID, "LET THE WATERS UNDER THE SKY BE GATHERED TO ONE PLACE, AND LET THE DRY GROUND APPEAR." GOD CALLED THE DRY GROUND "LAND" AND THE WATERS "SEAS." AND GOD SAW THAT IT WAS GOOD.

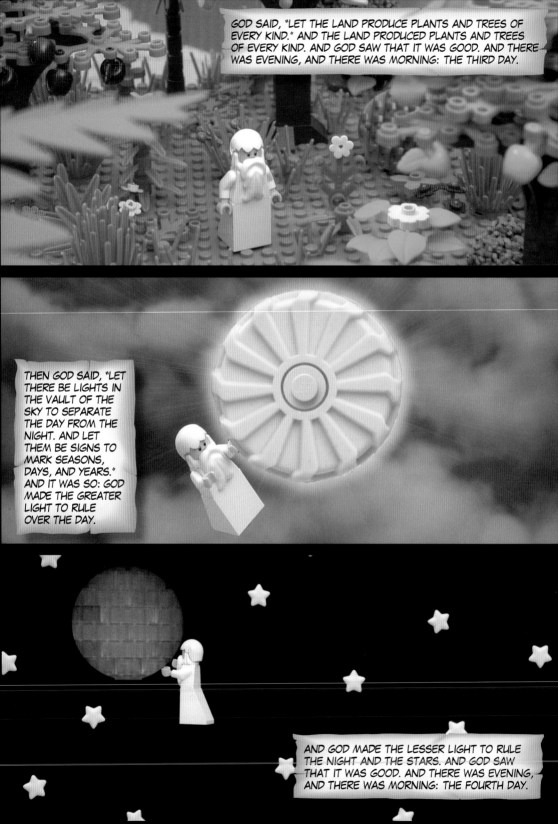

GOD SAID, "LET THE LAND PRODUCE PLANTS AND TREES OF EVERY KIND." AND THE LAND PRODUCED PLANTS AND TREES OF EVERY KIND. AND GOD SAW THAT IT WAS GOOD. AND THERE WAS EVENING, AND THERE WAS MORNING: THE THIRD DAY.

THEN GOD SAID, "LET THERE BE LIGHTS IN THE VAULT OF THE SKY TO SEPARATE THE DAY FROM THE NIGHT. AND LET THEM BE SIGNS TO MARK SEASONS, DAYS, AND YEARS." AND IT WAS SO: GOD MADE THE GREATER LIGHT TO RULE OVER THE DAY.

AND GOD MADE THE LESSER LIGHT TO RULE THE NIGHT AND THE STARS. AND GOD SAW THAT IT WAS GOOD. AND THERE WAS EVENING, AND THERE WAS MORNING: THE FOURTH DAY.

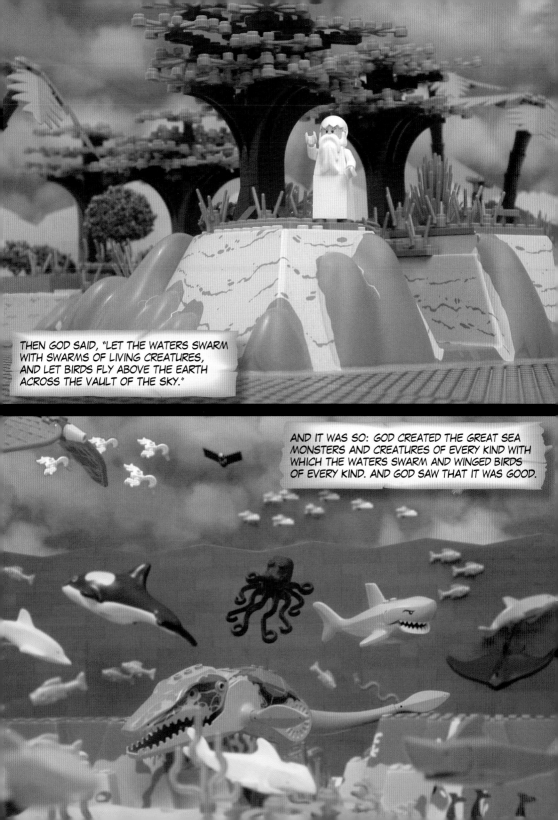

THEN GOD SAID, "LET THE WATERS SWARM WITH SWARMS OF LIVING CREATURES, AND LET BIRDS FLY ABOVE THE EARTH ACROSS THE VAULT OF THE SKY."

AND IT WAS SO: GOD CREATED THE GREAT SEA MONSTERS AND CREATURES OF EVERY KIND WITH WHICH THE WATERS SWARM AND WINGED BIRDS OF EVERY KIND. AND GOD SAW THAT IT WAS GOOD.

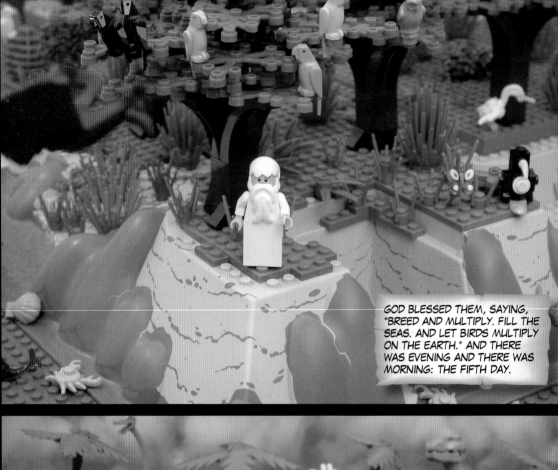

GOD BLESSED THEM, SAYING, "BREED AND MULTIPLY. FILL THE SEAS. AND LET BIRDS MULTIPLY ON THE EARTH." AND THERE WAS EVENING AND THERE WAS MORNING: THE FIFTH DAY.

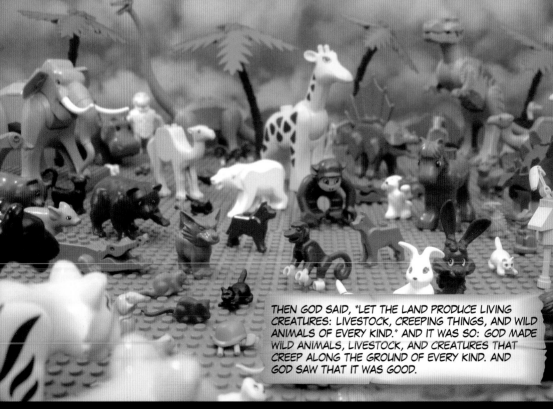

THEN GOD SAID, "LET THE LAND PRODUCE LIVING CREATURES: LIVESTOCK, CREEPING THINGS, AND WILD ANIMALS OF EVERY KIND." AND IT WAS SO: GOD MADE WILD ANIMALS, LIVESTOCK, AND CREATURES THAT CREEP ALONG THE GROUND OF EVERY KIND. AND GOD SAW THAT IT WAS GOOD.

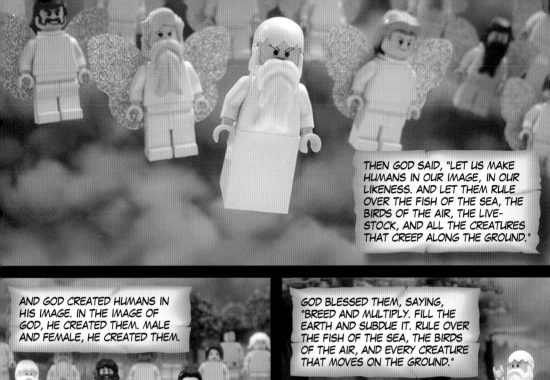

THEN GOD SAID, "LET US MAKE HUMANS IN OUR IMAGE, IN OUR LIKENESS. AND LET THEM RULE OVER THE FISH OF THE SEA, THE BIRDS OF THE AIR, THE LIVE-STOCK, AND ALL THE CREATURES THAT CREEP ALONG THE GROUND."

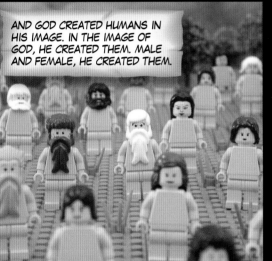

AND GOD CREATED HUMANS IN HIS IMAGE. IN THE IMAGE OF GOD, HE CREATED THEM. MALE AND FEMALE, HE CREATED THEM.

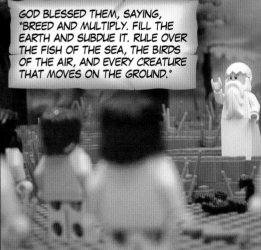

GOD BLESSED THEM, SAYING, "BREED AND MULTIPLY. FILL THE EARTH AND SUBDUE IT. RULE OVER THE FISH OF THE SEA, THE BIRDS OF THE AIR, AND EVERY CREATURE THAT MOVES ON THE GROUND."

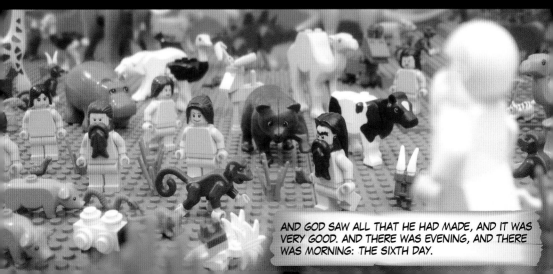

AND GOD SAW ALL THAT HE HAD MADE, AND IT WAS VERY GOOD. AND THERE WAS EVENING, AND THERE WAS MORNING: THE SIXTH DAY.

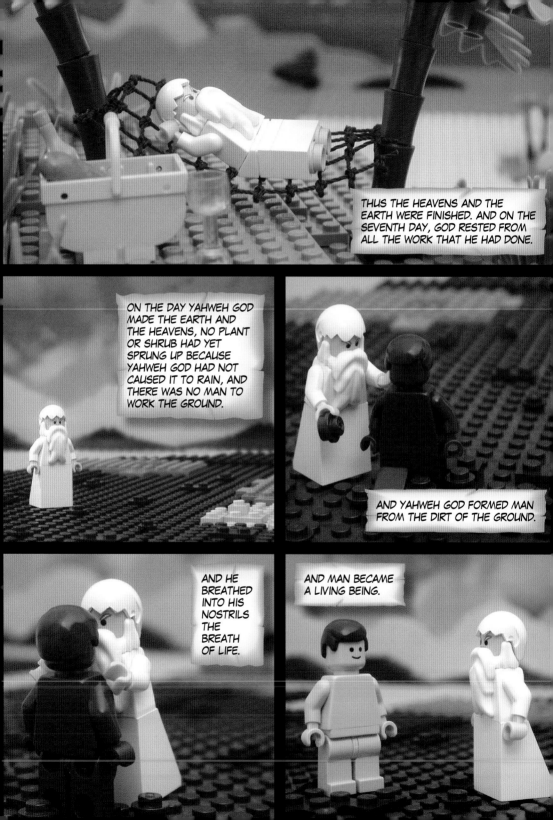

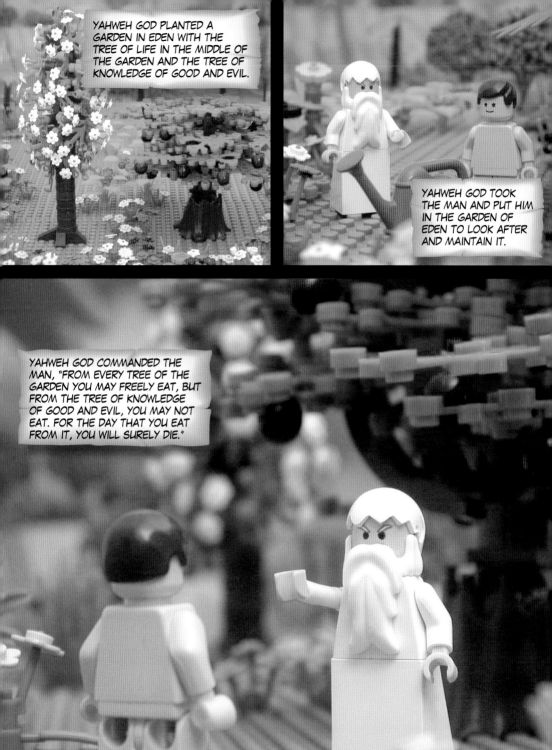

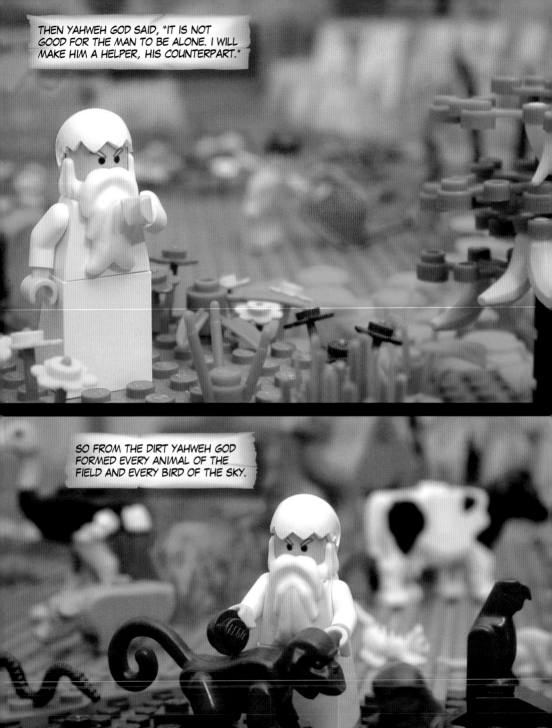

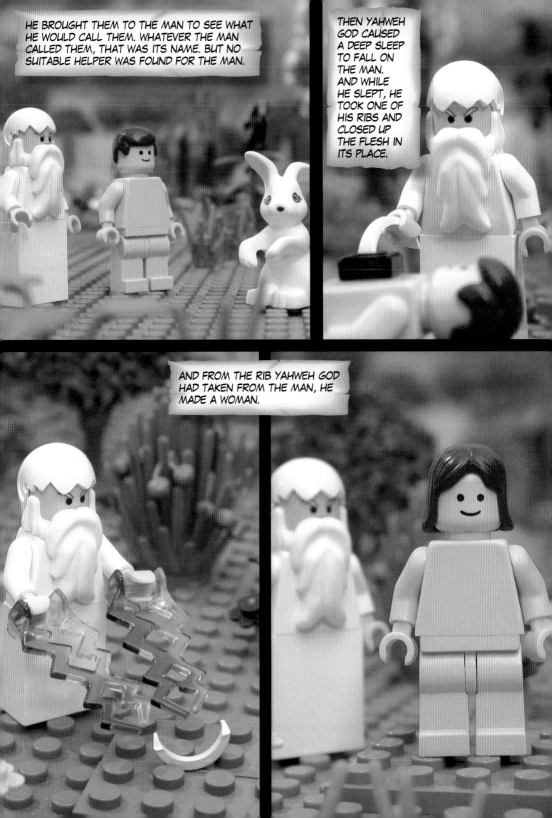

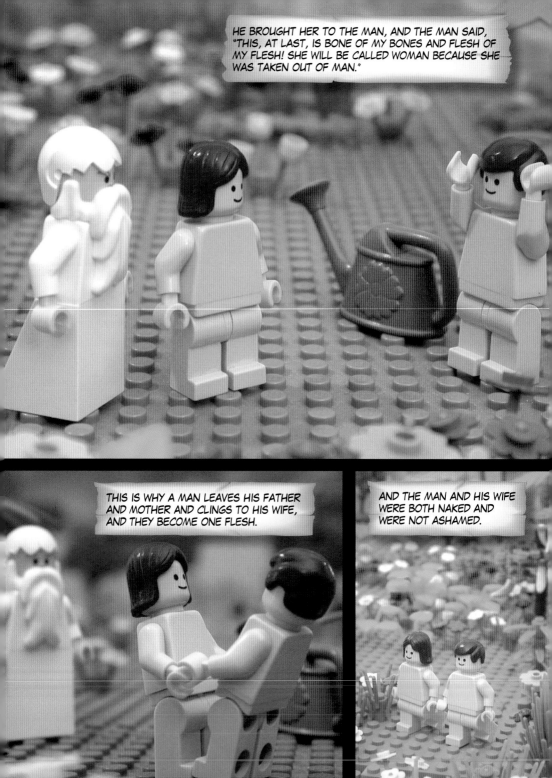

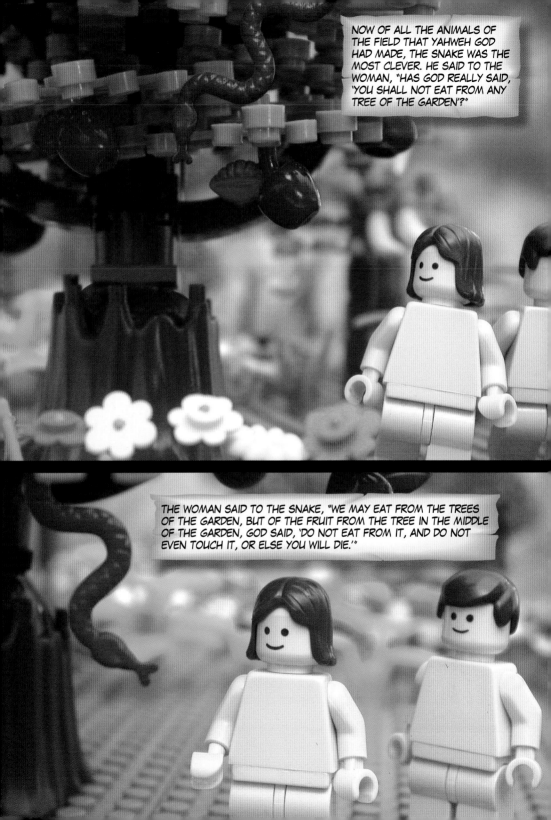

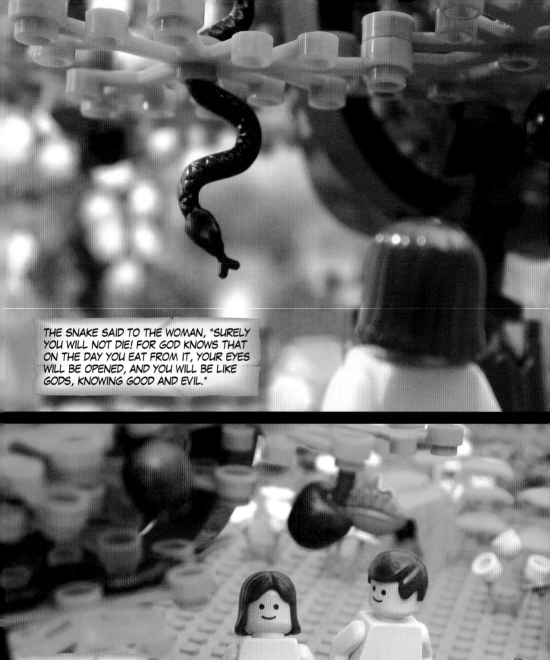

THE SNAKE SAID TO THE WOMAN, "SURELY YOU WILL NOT DIE! FOR GOD KNOWS THAT ON THE DAY YOU EAT FROM IT, YOUR EYES WILL BE OPENED, AND YOU WILL BE LIKE GODS, KNOWING GOOD AND EVIL."

THE WOMAN SAW THAT THE TREE WAS GOOD FOR FOOD, PLEASING TO THE EYES, AND DESIRABLE FOR THE KNOWLEDGE IT COULD GIVE.

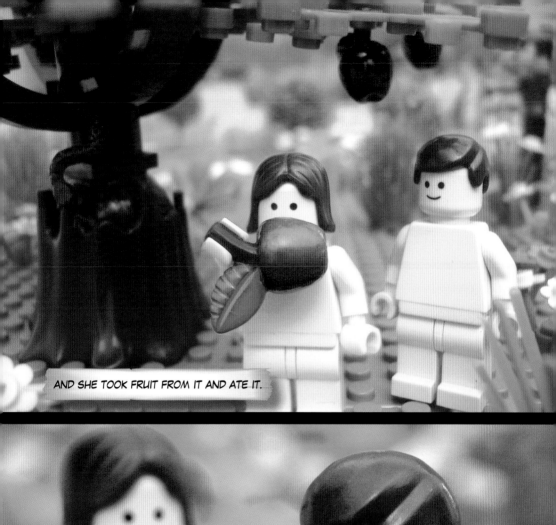

AND SHE TOOK FRUIT FROM IT AND ATE IT.

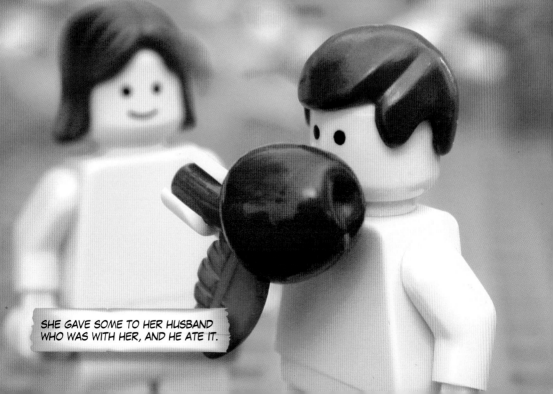

SHE GAVE SOME TO HER HUSBAND
WHO WAS WITH HER, AND HE ATE IT.

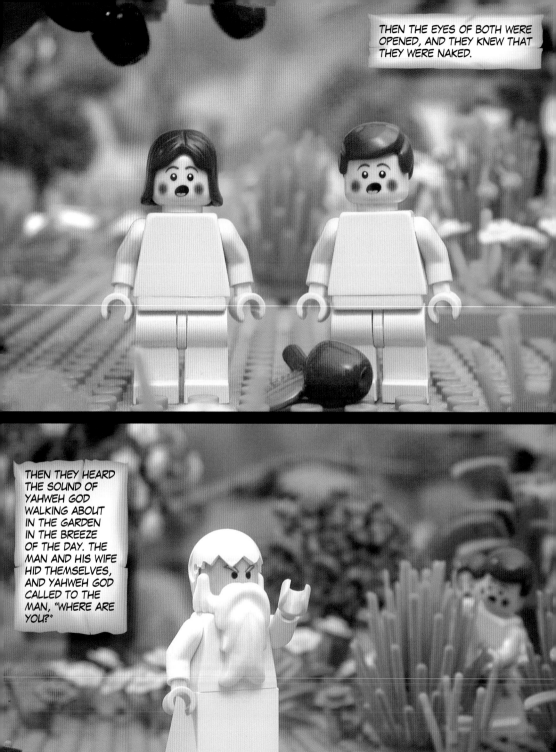

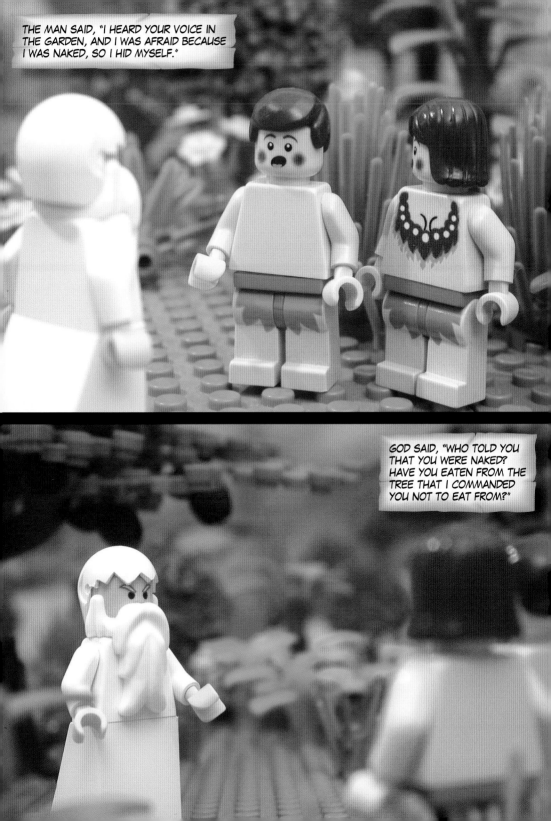

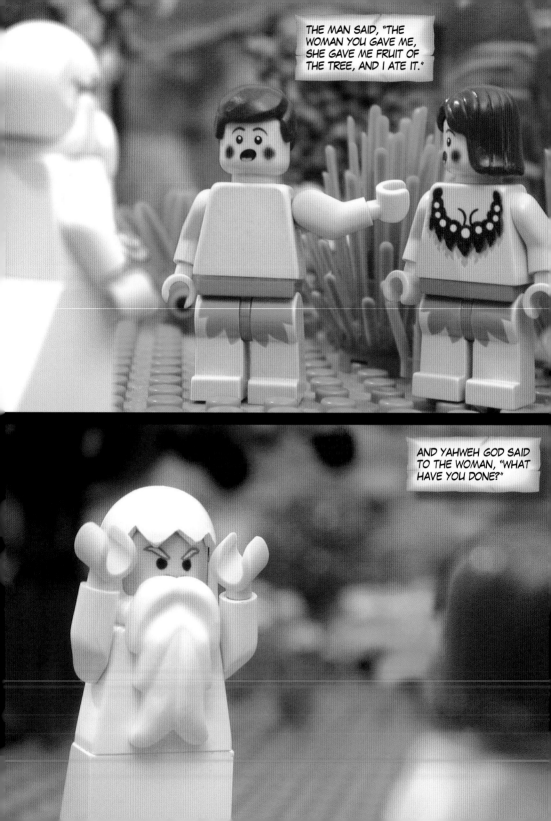

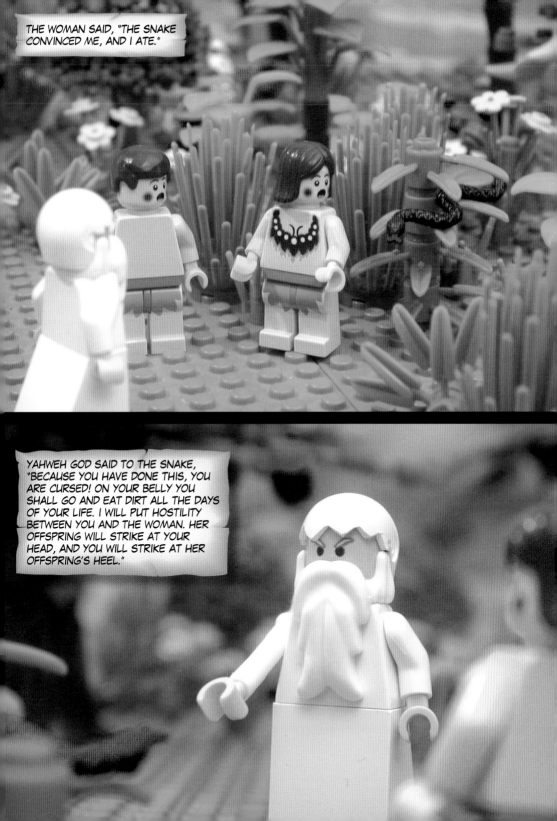

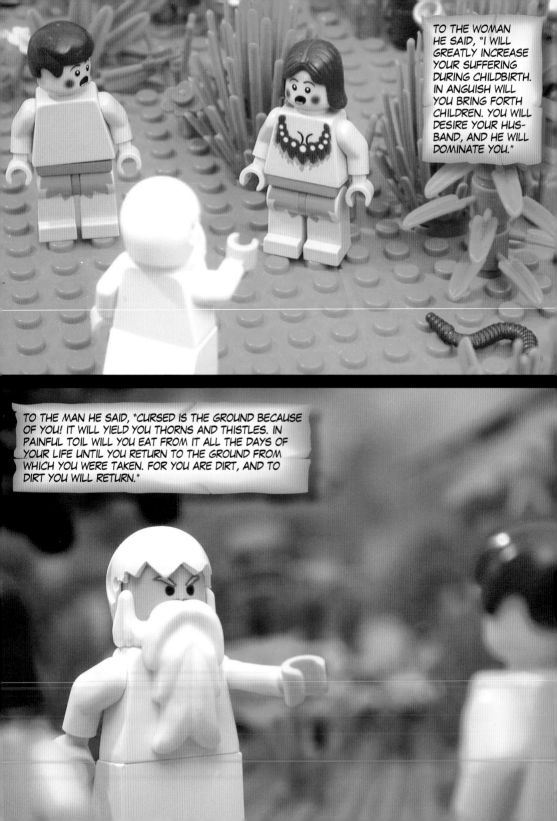

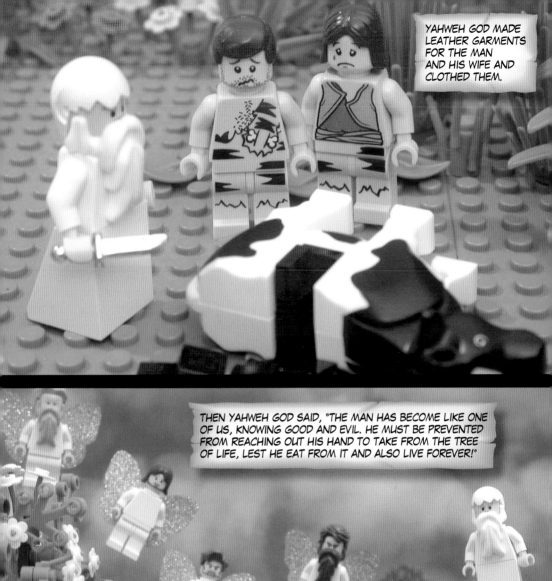

YAHWEH GOD MADE LEATHER GARMENTS FOR THE MAN AND HIS WIFE AND CLOTHED THEM.

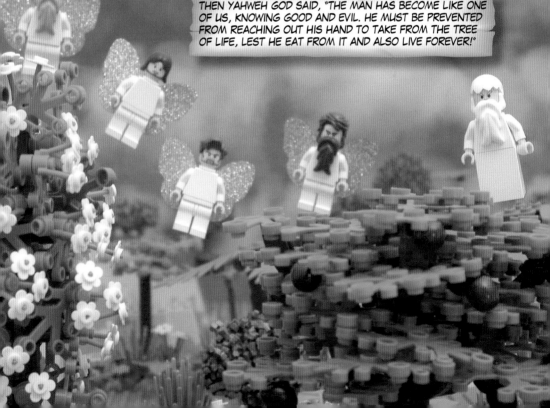

THEN YAHWEH GOD SAID, "THE MAN HAS BECOME LIKE ONE OF US, KNOWING GOOD AND EVIL. HE MUST BE PREVENTED FROM REACHING OUT HIS HAND TO TAKE FROM THE TREE OF LIFE, LEST HE EAT FROM IT AND ALSO LIVE FOREVER!"

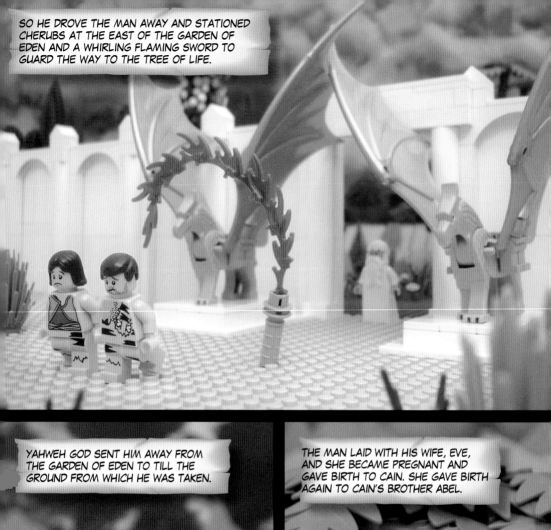

SO HE DROVE THE MAN AWAY AND STATIONED CHERUBS AT THE EAST OF THE GARDEN OF EDEN AND A WHIRLING FLAMING SWORD TO GUARD THE WAY TO THE TREE OF LIFE.

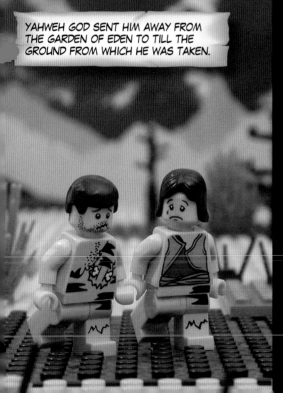

YAHWEH GOD SENT HIM AWAY FROM THE GARDEN OF EDEN TO TILL THE GROUND FROM WHICH HE WAS TAKEN.

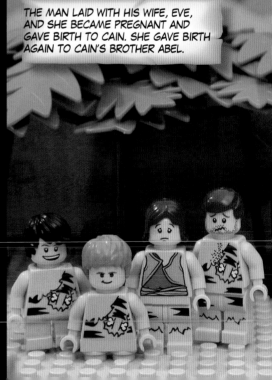

THE MAN LAID WITH HIS WIFE, EVE, AND SHE BECAME PREGNANT AND GAVE BIRTH TO CAIN. SHE GAVE BIRTH AGAIN TO CAIN'S BROTHER ABEL.

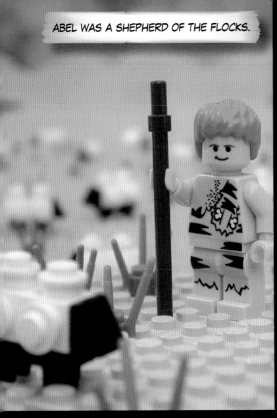

ABEL WAS A SHEPHERD OF THE FLOCKS.

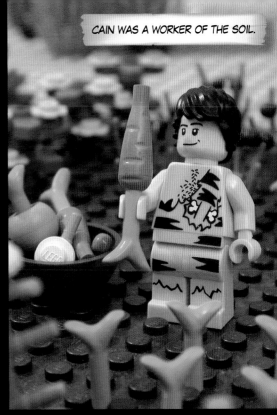

CAIN WAS A WORKER OF THE SOIL.

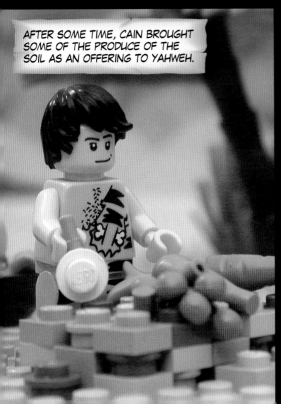

AFTER SOME TIME, CAIN BROUGHT SOME OF THE PRODUCE OF THE SOIL AS AN OFFERING TO YAHWEH.

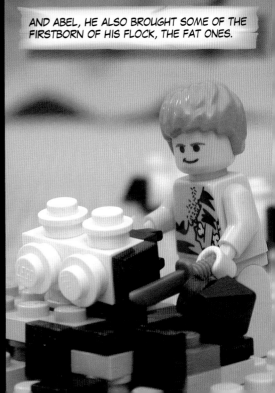

AND ABEL, HE ALSO BROUGHT SOME OF THE FIRSTBORN OF HIS FLOCK, THE FAT ONES.

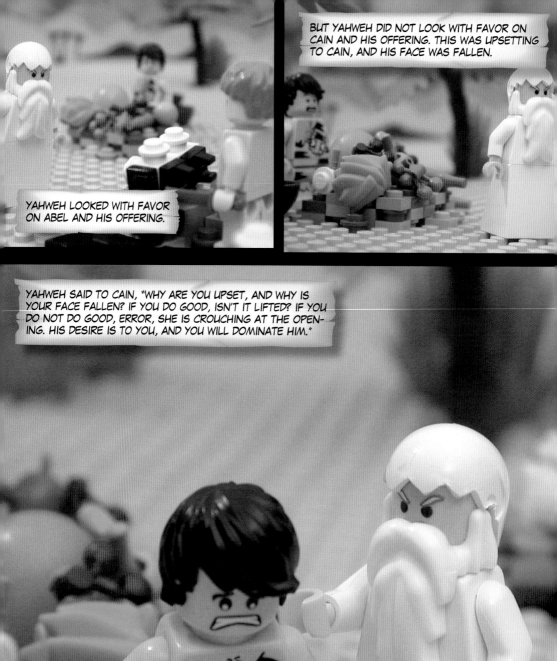

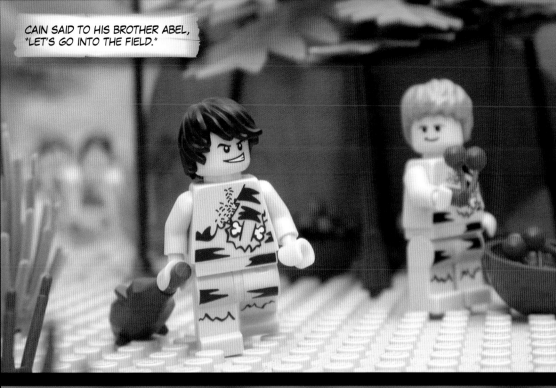

CAIN SAID TO HIS BROTHER ABEL, "LET'S GO INTO THE FIELD."

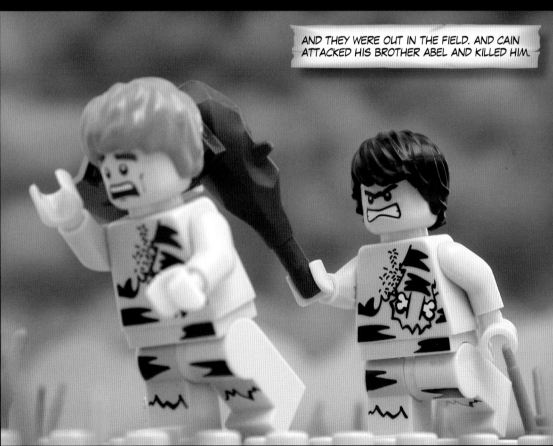

AND THEY WERE OUT IN THE FIELD. AND CAIN ATTACKED HIS BROTHER ABEL AND KILLED HIM.

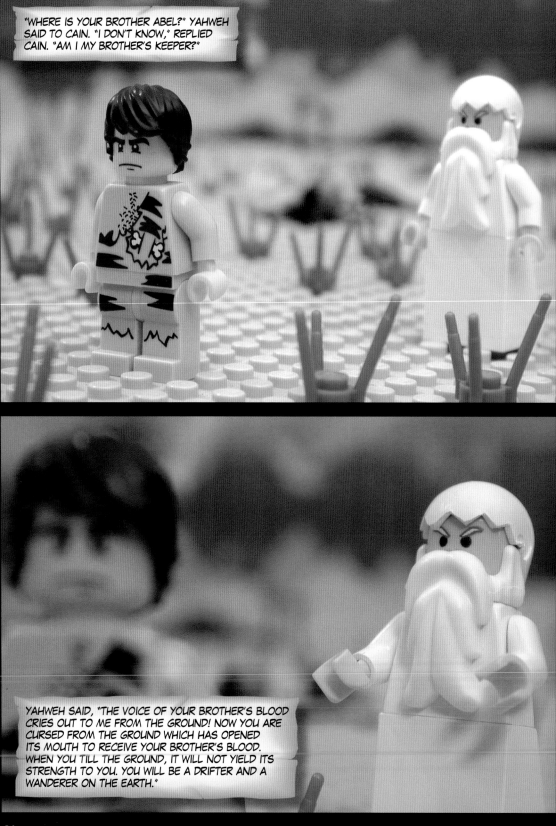

"WHERE IS YOUR BROTHER ABEL?" YAHWEH SAID TO CAIN. "I DON'T KNOW," REPLIED CAIN. "AM I MY BROTHER'S KEEPER?"

YAHWEH SAID, "THE VOICE OF YOUR BROTHER'S BLOOD CRIES OUT TO ME FROM THE GROUND! NOW YOU ARE CURSED FROM THE GROUND WHICH HAS OPENED ITS MOUTH TO RECEIVE YOUR BROTHER'S BLOOD. WHEN YOU TILL THE GROUND, IT WILL NOT YIELD ITS STRENGTH TO YOU. YOU WILL BE A DRIFTER AND A WANDERER ON THE EARTH."

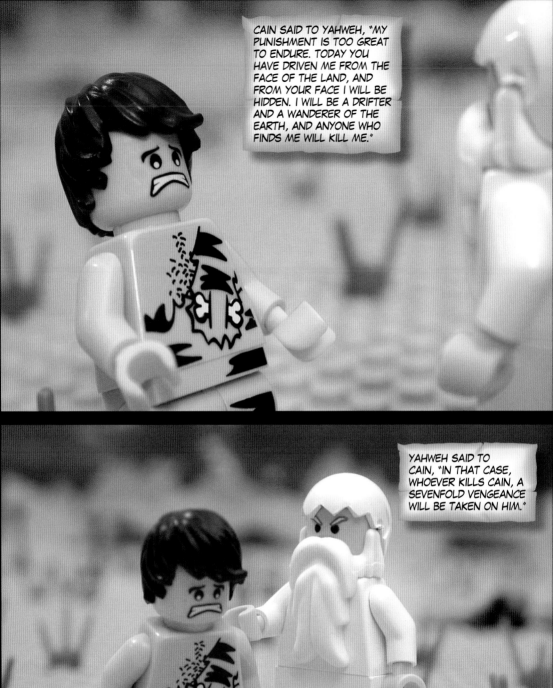

CAIN SAID TO YAHWEH, "MY PUNISHMENT IS TOO GREAT TO ENDURE. TODAY YOU HAVE DRIVEN ME FROM THE FACE OF THE LAND, AND FROM YOUR FACE I WILL BE HIDDEN. I WILL BE A DRIFTER AND A WANDERER OF THE EARTH, AND ANYONE WHO FINDS ME WILL KILL ME."

YAHWEH SAID TO CAIN, "IN THAT CASE, WHOEVER KILLS CAIN, A SEVENFOLD VENGEANCE WILL BE TAKEN ON HIM."

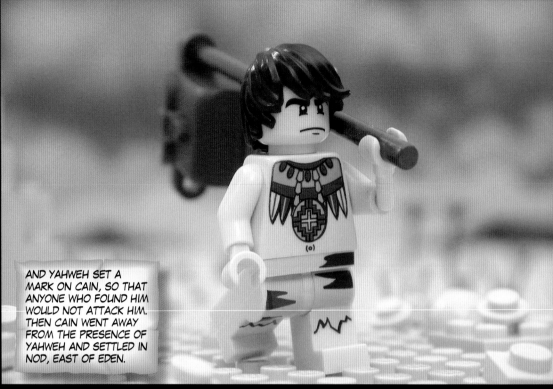

AND YAHWEH SET A MARK ON CAIN, SO THAT ANYONE WHO FOUND HIM WOULD NOT ATTACK HIM. THEN CAIN WENT AWAY FROM THE PRESENCE OF YAHWEH AND SETTLED IN NOD, EAST OF EDEN.

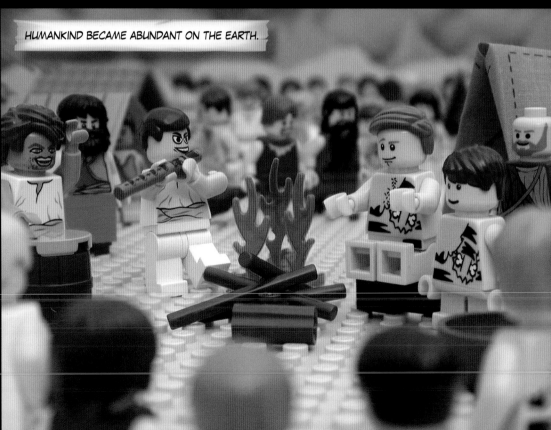

HUMANKIND BECAME ABUNDANT ON THE EARTH.

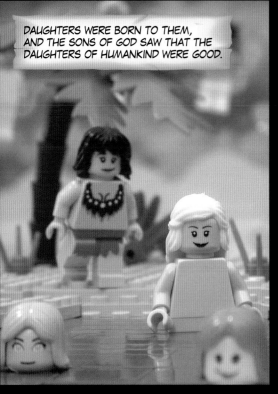

DAUGHTERS WERE BORN TO THEM, AND THE SONS OF GOD SAW THAT THE DAUGHTERS OF HUMANKIND WERE GOOD.

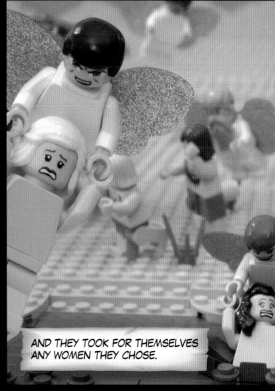

AND THEY TOOK FOR THEMSELVES ANY WOMEN THEY CHOSE.

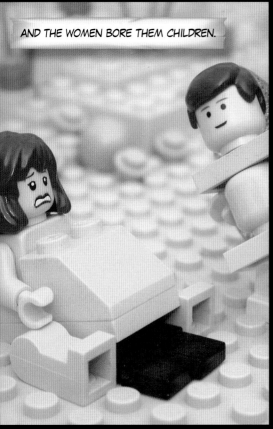

AND THE WOMEN BORE THEM CHILDREN.

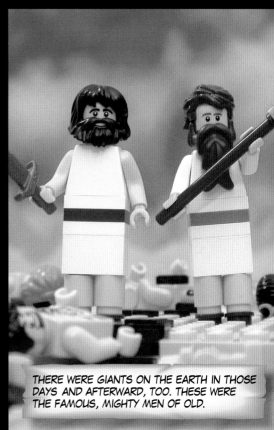

THERE WERE GIANTS ON THE EARTH IN THOSE DAYS AND AFTERWARD, TOO. THESE WERE THE FAMOUS, MIGHTY MEN OF OLD.

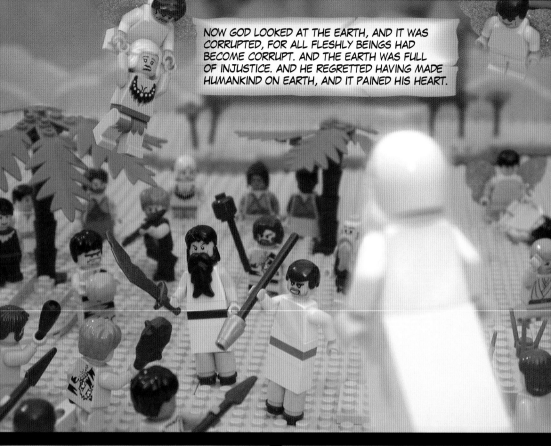

NOW GOD LOOKED AT THE EARTH, AND IT WAS CORRUPTED, FOR ALL FLESHLY BEINGS HAD BECOME CORRUPT. AND THE EARTH WAS FULL OF INJUSTICE. AND HE REGRETTED HAVING MADE HUMANKIND ON EARTH, AND IT PAINED HIS HEART.

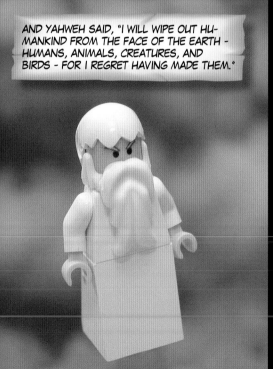

AND YAHWEH SAID, "I WILL WIPE OUT HUMANKIND FROM THE FACE OF THE EARTH - HUMANS, ANIMALS, CREATURES, AND BIRDS - FOR I REGRET HAVING MADE THEM."

BUT NOAH FOUND FAVOR IN YAHWEH'S EYES. NOAH WAS A JUST MAN AND PERFECT AMONG HIS GENERATION. HE WALKED WITH GOD.

GOD SAID TO NOAH, "I AM ABOUT TO BRING WATERS TO FLOOD THE EARTH AND DESTROY EVERY LIVING CREATURE UNDER THE HEAVENS. EVERYTHING ON THE EARTH WILL DIE. I WILL SEND RAIN FOR 40 DAYS AND 40 NIGHTS, AND I WILL WIPE OUT EVERY LIVING THING FROM THE FACE OF THE EARTH."

"BUT I WILL MAKE MY PACT WITH YOU. MAKE YOURSELF AN ARK OF GOPHER WOOD." NOAH DID ALL THAT GOD COMMANDED HIM TO DO. GOD SAID, "HERE IS HOW YOU SHOULD MAKE IT: 450 FEET LONG, 75 FEET WIDE."

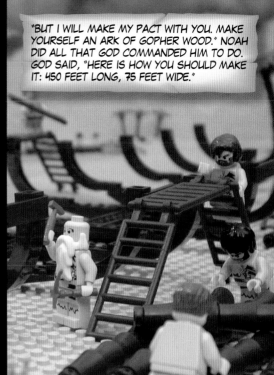

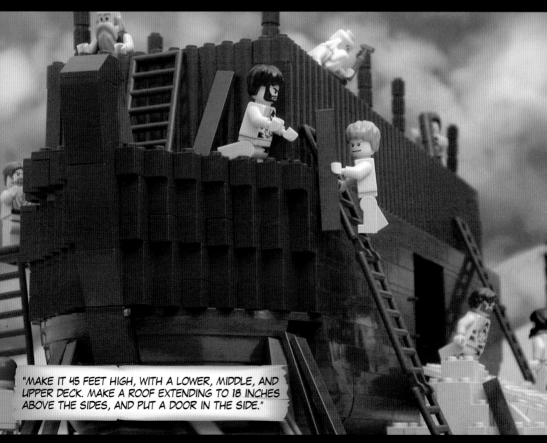

"MAKE IT 45 FEET HIGH, WITH A LOWER, MIDDLE, AND UPPER DECK. MAKE A ROOF EXTENDING TO 18 INCHES ABOVE THE SIDES, AND PUT A DOOR IN THE SIDE."

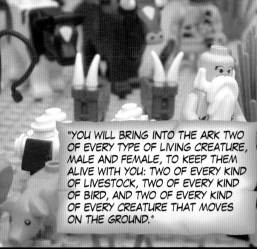

"YOU WILL BRING INTO THE ARK TWO OF EVERY TYPE OF LIVING CREATURE, MALE AND FEMALE, TO KEEP THEM ALIVE WITH YOU: TWO OF EVERY KIND OF LIVESTOCK, TWO OF EVERY KIND OF BIRD, AND TWO OF EVERY KIND OF EVERY CREATURE THAT MOVES ON THE GROUND."

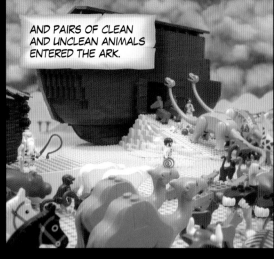

AND PAIRS OF CLEAN AND UNCLEAN ANIMALS ENTERED THE ARK.

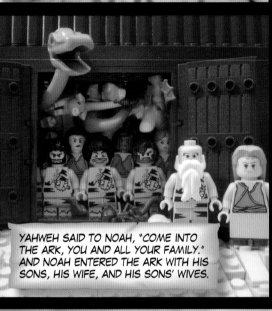

YAHWEH SAID TO NOAH, "COME INTO THE ARK, YOU AND ALL YOUR FAMILY." AND NOAH ENTERED THE ARK WITH HIS SONS, HIS WIFE, AND HIS SONS' WIVES.

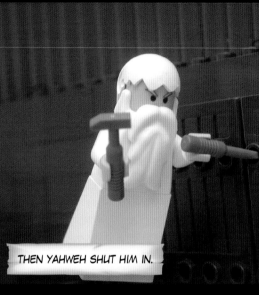

THEN YAHWEH SHUT HIM IN.

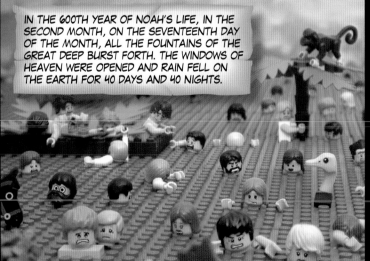

IN THE 600TH YEAR OF NOAH'S LIFE, IN THE SECOND MONTH, ON THE SEVENTEENTH DAY OF THE MONTH, ALL THE FOUNTAINS OF THE GREAT DEEP BURST FORTH. THE WINDOWS OF HEAVEN WERE OPENED AND RAIN FELL ON THE EARTH FOR 40 DAYS AND 40 NIGHTS.

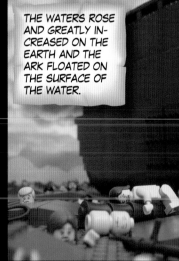

THE WATERS ROSE AND GREATLY IN-CREASED ON THE EARTH AND THE ARK FLOATED ON THE SURFACE OF THE WATER.

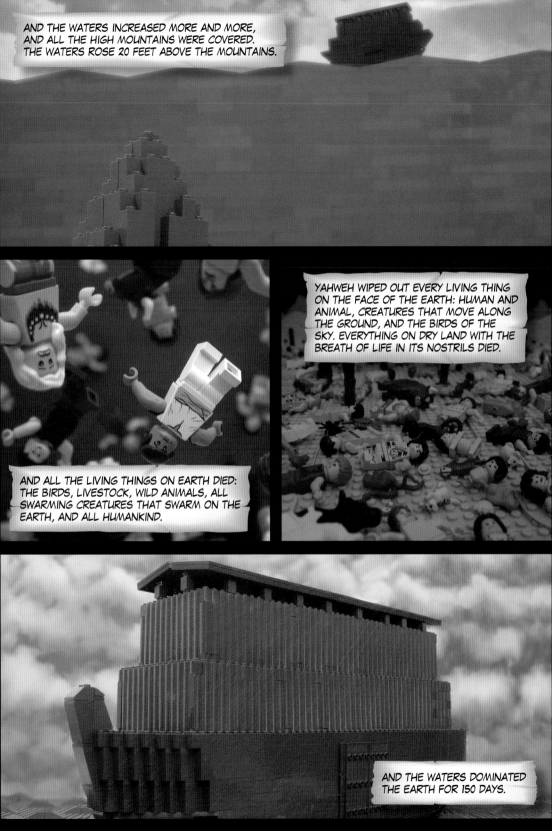

AND THE WATERS INCREASED MORE AND MORE, AND ALL THE HIGH MOUNTAINS WERE COVERED. THE WATERS ROSE 20 FEET ABOVE THE MOUNTAINS.

YAHWEH WIPED OUT EVERY LIVING THING ON THE FACE OF THE EARTH: HUMAN AND ANIMAL, CREATURES THAT MOVE ALONG THE GROUND, AND THE BIRDS OF THE SKY. EVERYTHING ON DRY LAND WITH THE BREATH OF LIFE IN ITS NOSTRILS DIED.

AND ALL THE LIVING THINGS ON EARTH DIED: THE BIRDS, LIVESTOCK, WILD ANIMALS, ALL SWARMING CREATURES THAT SWARM ON THE EARTH, AND ALL HUMANKIND.

AND THE WATERS DOMINATED THE EARTH FOR 150 DAYS.

33

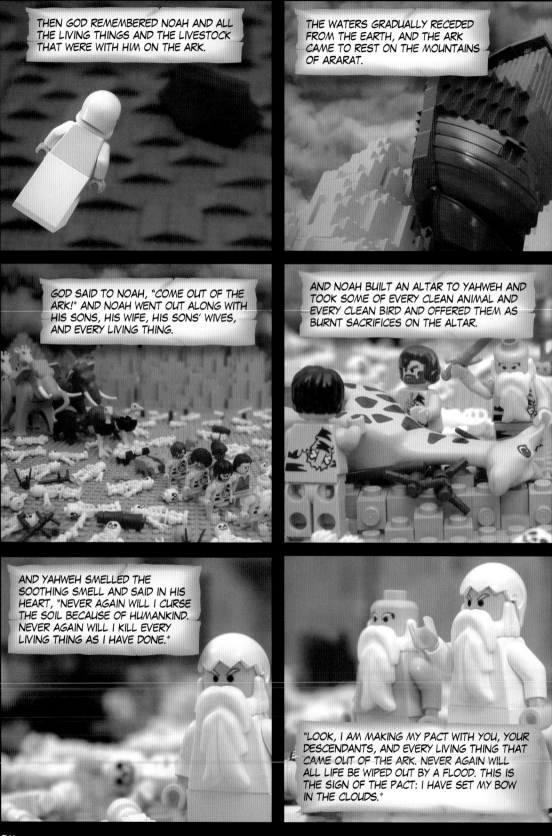

THEN GOD REMEMBERED NOAH AND ALL THE LIVING THINGS AND THE LIVESTOCK THAT WERE WITH HIM ON THE ARK.

THE WATERS GRADUALLY RECEDED FROM THE EARTH, AND THE ARK CAME TO REST ON THE MOUNTAINS OF ARARAT.

GOD SAID TO NOAH, "COME OUT OF THE ARK!" AND NOAH WENT OUT ALONG WITH HIS SONS, HIS WIFE, HIS SONS' WIVES, AND EVERY LIVING THING.

AND NOAH BUILT AN ALTAR TO YAHWEH AND TOOK SOME OF EVERY CLEAN ANIMAL AND EVERY CLEAN BIRD AND OFFERED THEM AS BURNT SACRIFICES ON THE ALTAR.

AND YAHWEH SMELLED THE SOOTHING SMELL AND SAID IN HIS HEART, "NEVER AGAIN WILL I CURSE THE SOIL BECAUSE OF HUMANKIND. NEVER AGAIN WILL I KILL EVERY LIVING THING AS I HAVE DONE."

"LOOK, I AM MAKING MY PACT WITH YOU, YOUR DESCENDANTS, AND EVERY LIVING THING THAT CAME OUT OF THE ARK. NEVER AGAIN WILL ALL LIFE BE WIPED OUT BY A FLOOD. THIS IS THE SIGN OF THE PACT: I HAVE SET MY BOW IN THE CLOUDS."

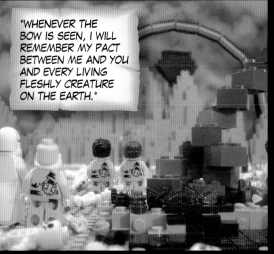

"WHENEVER THE BOW IS SEEN, I WILL REMEMBER MY PACT BETWEEN ME AND YOU AND EVERY LIVING FLESHLY CREATURE ON THE EARTH."

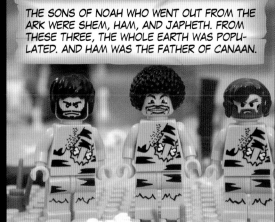

THE SONS OF NOAH WHO WENT OUT FROM THE ARK WERE SHEM, HAM, AND JAPHETH. FROM THESE THREE, THE WHOLE EARTH WAS POPULATED. AND HAM WAS THE FATHER OF CANAAN.

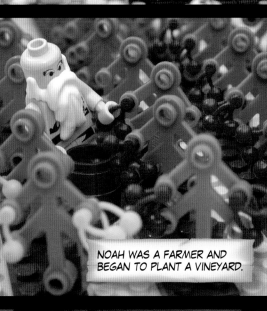

NOAH WAS A FARMER AND BEGAN TO PLANT A VINEYARD.

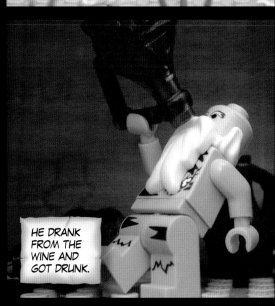

HE DRANK FROM THE WINE AND GOT DRUNK.

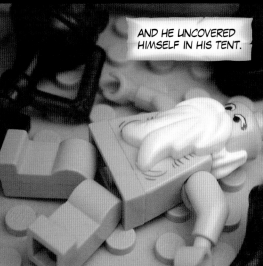

AND HE UNCOVERED HIMSELF IN HIS TENT.

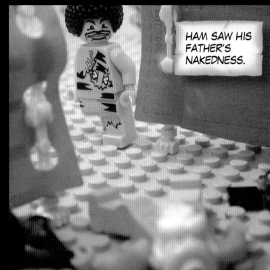

HAM SAW HIS FATHER'S NAKEDNESS.

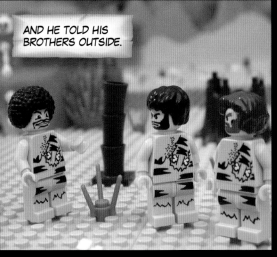

AND HE TOLD HIS BROTHERS OUTSIDE.

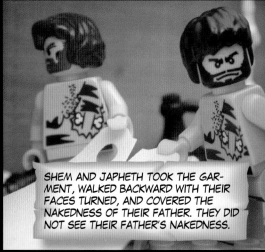

SHEM AND JAPHETH TOOK THE GARMENT, WALKED BACKWARD WITH THEIR FACES TURNED, AND COVERED THE NAKEDNESS OF THEIR FATHER. THEY DID NOT SEE THEIR FATHER'S NAKEDNESS.

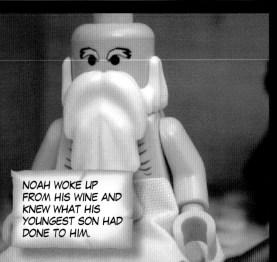

NOAH WOKE UP FROM HIS WINE AND KNEW WHAT HIS YOUNGEST SON HAD DONE TO HIM.

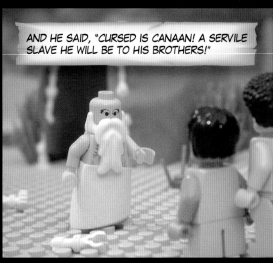

AND HE SAID, "CURSED IS CANAAN! A SERVILE SLAVE HE WILL BE TO HIS BROTHERS!"

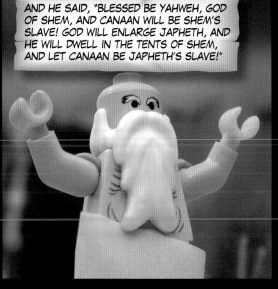

AND HE SAID, "BLESSED BE YAHWEH, GOD OF SHEM, AND CANAAN WILL BE SHEM'S SLAVE! GOD WILL ENLARGE JAPHETH, AND HE WILL DWELL IN THE TENTS OF SHEM, AND LET CANAAN BE JAPHETH'S SLAVE!"

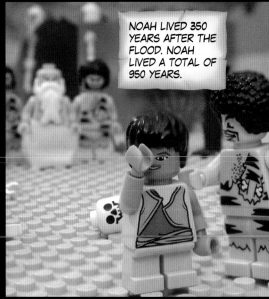

NOAH LIVED 350 YEARS AFTER THE FLOOD. NOAH LIVED A TOTAL OF 950 YEARS.

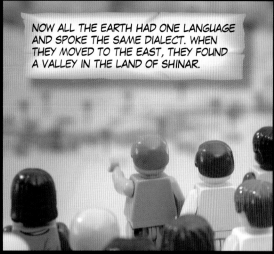

NOW ALL THE EARTH HAD ONE LANGUAGE AND SPOKE THE SAME DIALECT. WHEN THEY MOVED TO THE EAST, THEY FOUND A VALLEY IN THE LAND OF SHINAR.

THEN HE DIED.

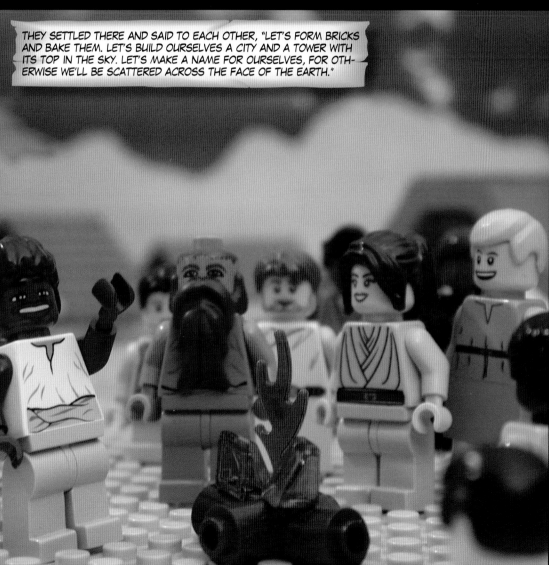

THEY SETTLED THERE AND SAID TO EACH OTHER, "LET'S FORM BRICKS AND BAKE THEM. LET'S BUILD OURSELVES A CITY AND A TOWER WITH ITS TOP IN THE SKY. LET'S MAKE A NAME FOR OURSELVES, FOR OTHERWISE WE'LL BE SCATTERED ACROSS THE FACE OF THE EARTH."

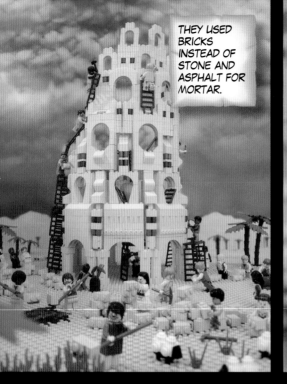

THEY USED BRICKS INSTEAD OF STONE AND ASPHALT FOR MORTAR.

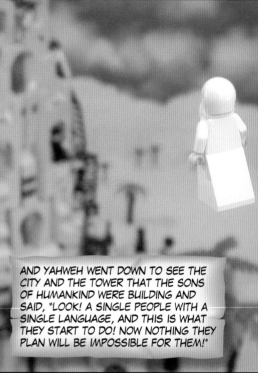

AND YAHWEH WENT DOWN TO SEE THE CITY AND THE TOWER THAT THE SONS OF HUMANKIND WERE BUILDING AND SAID, "LOOK! A SINGLE PEOPLE WITH A SINGLE LANGUAGE, AND THIS IS WHAT THEY START TO DO! NOW NOTHING THEY PLAN WILL BE IMPOSSIBLE FOR THEM!"

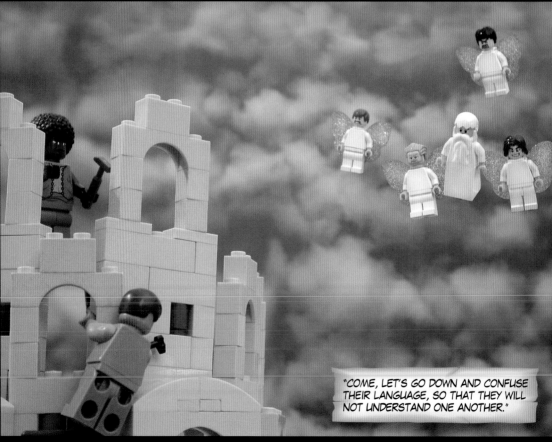

"COME, LET'S GO DOWN AND CONFUSE THEIR LANGUAGE, SO THAT THEY WILL NOT UNDERSTAND ONE ANOTHER."

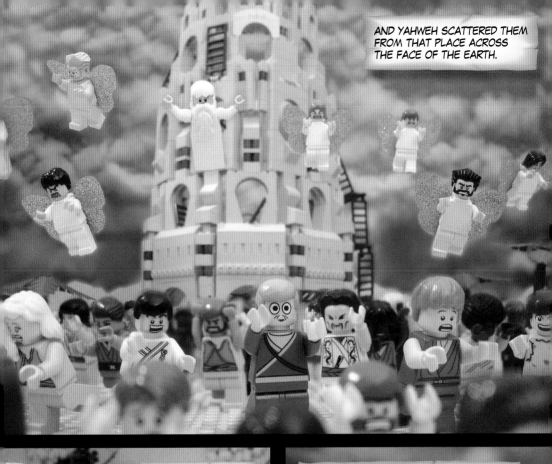

AND YAHWEH SCATTERED THEM FROM THAT PLACE ACROSS THE FACE OF THE EARTH.

AND THEY STOPPED BUILDING THE CITY.

THAT IS WHY IT WAS CALLED BABEL, BECAUSE THERE YAHWEH CONFUSED THE LANGUAGE OF ALL THE EARTH. AND YAHWEH SCATTERED THEM FROM THAT PLACE ACROSS THE FACE OF THE EARTH.

NOW TERAH TOOK HIS SON ABRAM AND HIS WIFE SARAI AND HIS GRANDSON LOT, AND THEY SET OUT FROM UR TOWARD THE LAND OF CANAAN. SARAI WAS INFERTILE AND HAD NO CHILDREN.

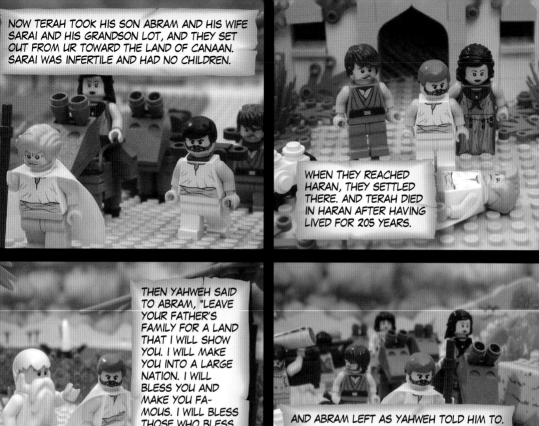

WHEN THEY REACHED HARAN, THEY SETTLED THERE. AND TERAH DIED IN HARAN AFTER HAVING LIVED FOR 205 YEARS.

THEN YAHWEH SAID TO ABRAM, "LEAVE YOUR FATHER'S FAMILY FOR A LAND THAT I WILL SHOW YOU. I WILL MAKE YOU INTO A LARGE NATION. I WILL BLESS YOU AND MAKE YOU FAMOUS. I WILL BLESS THOSE WHO BLESS YOU, AND THOSE WHO MOCK YOU, I WILL CURSE!"

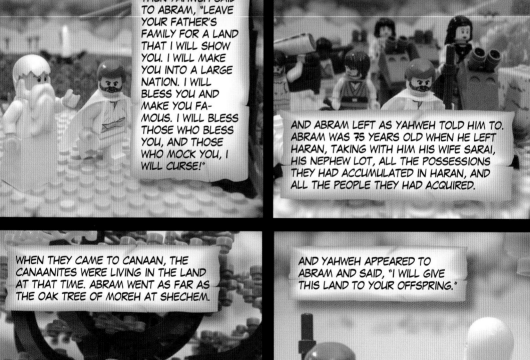

AND ABRAM LEFT AS YAHWEH TOLD HIM TO. ABRAM WAS 75 YEARS OLD WHEN HE LEFT HARAN, TAKING WITH HIM HIS WIFE SARAI, HIS NEPHEW LOT, ALL THE POSSESSIONS THEY HAD ACCUMULATED IN HARAN, AND ALL THE PEOPLE THEY HAD ACQUIRED.

WHEN THEY CAME TO CANAAN, THE CANAANITES WERE LIVING IN THE LAND AT THAT TIME. ABRAM WENT AS FAR AS THE OAK TREE OF MOREH AT SHECHEM.

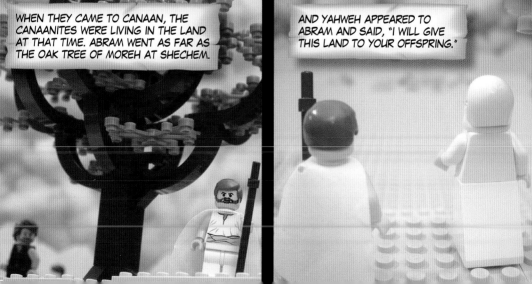

AND YAHWEH APPEARED TO ABRAM AND SAID, "I WILL GIVE THIS LAND TO YOUR OFFSPRING."

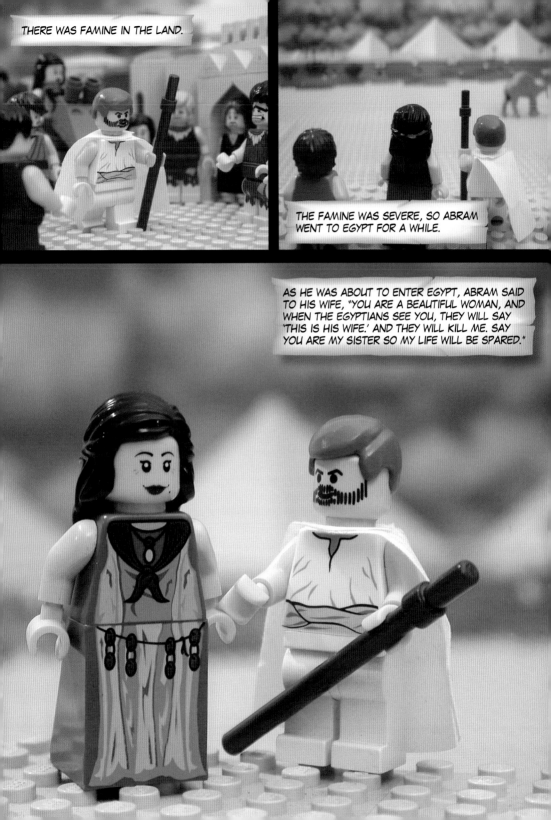

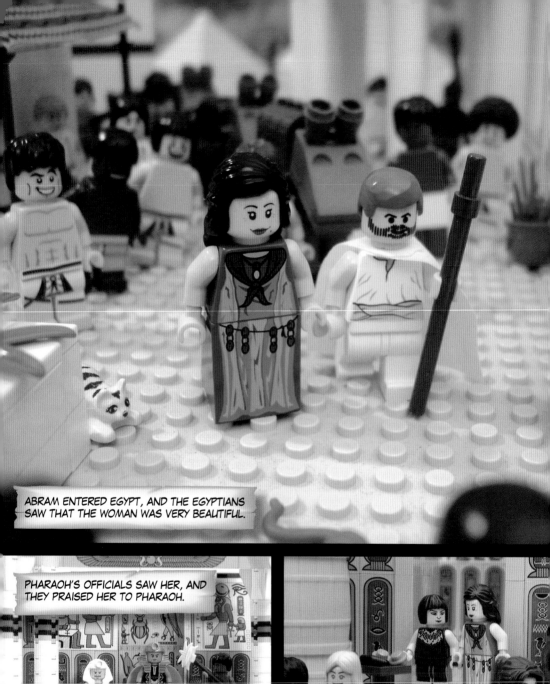

ABRAM ENTERED EGYPT, AND THE EGYPTIANS SAW THAT THE WOMAN WAS VERY BEAUTIFUL.

PHARAOH'S OFFICIALS SAW HER, AND THEY PRAISED HER TO PHARAOH.

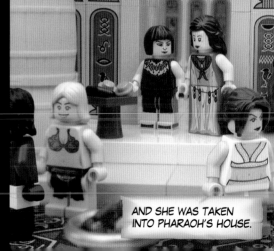

AND SHE WAS TAKEN INTO PHARAOH'S HOUSE.

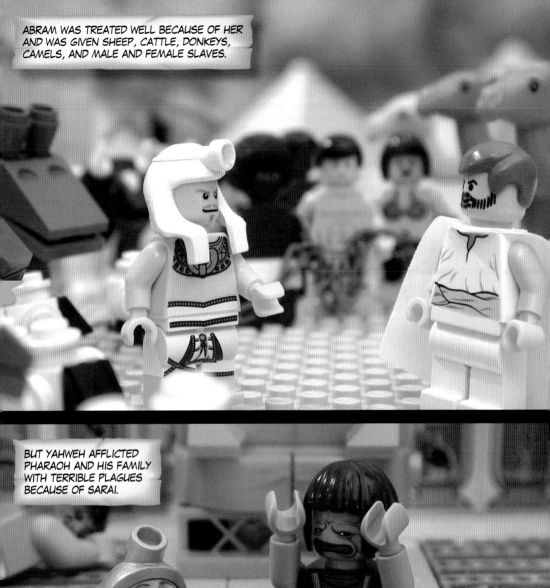

ABRAM WAS TREATED WELL BECAUSE OF HER AND WAS GIVEN SHEEP, CATTLE, DONKEYS, CAMELS, AND MALE AND FEMALE SLAVES.

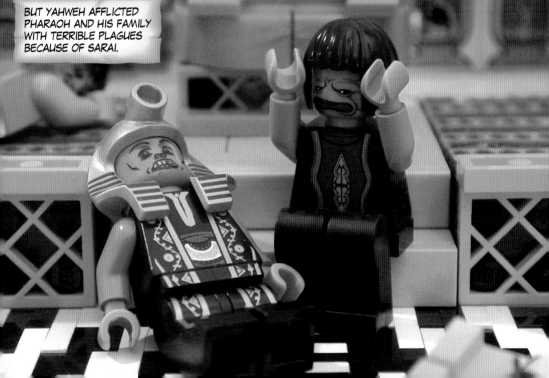

BUT YAHWEH AFFLICTED PHARAOH AND HIS FAMILY WITH TERRIBLE PLAGUES BECAUSE OF SARAI.

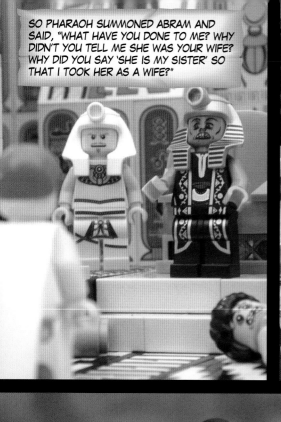

SO PHARAOH SUMMONED ABRAM AND SAID, "WHAT HAVE YOU DONE TO ME? WHY DIDN'T YOU TELL ME SHE WAS YOUR WIFE? WHY DID YOU SAY 'SHE IS MY SISTER' SO THAT I TOOK HER AS A WIFE?"

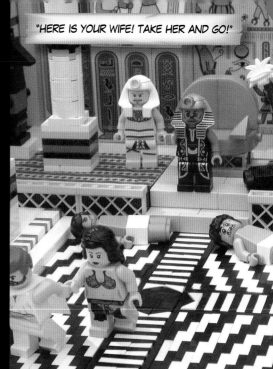

"HERE IS YOUR WIFE! TAKE HER AND GO!"

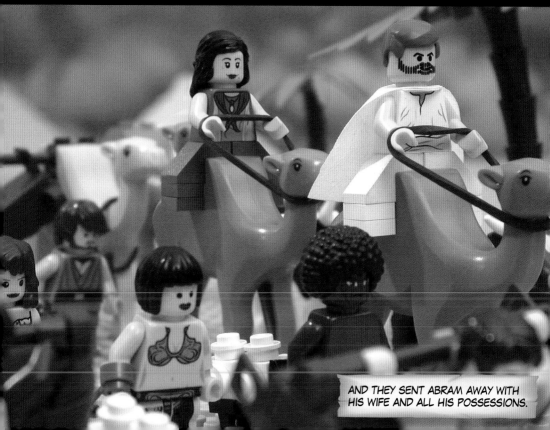

AND THEY SENT ABRAM AWAY WITH HIS WIFE AND ALL HIS POSSESSIONS.

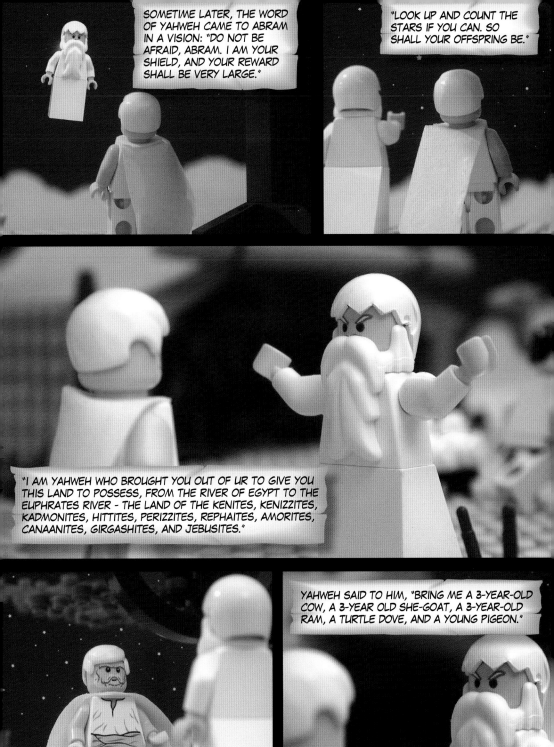

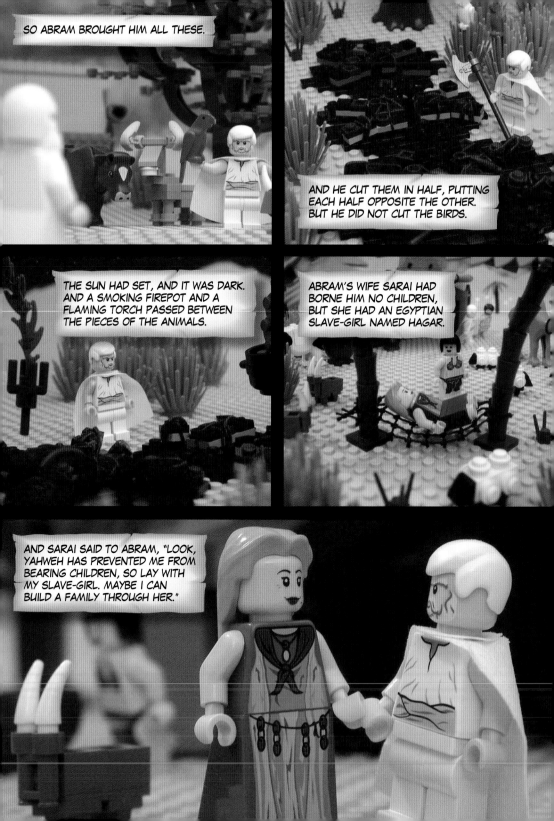

SO ABRAM BROUGHT HIM ALL THESE.

AND HE CUT THEM IN HALF, PUTTING EACH HALF OPPOSITE THE OTHER. BUT HE DID NOT CUT THE BIRDS.

THE SUN HAD SET, AND IT WAS DARK. AND A SMOKING FIREPOT AND A FLAMING TORCH PASSED BETWEEN THE PIECES OF THE ANIMALS.

ABRAM'S WIFE SARAI HAD BORNE HIM NO CHILDREN, BUT SHE HAD AN EGYPTIAN SLAVE-GIRL NAMED HAGAR.

AND SARAI SAID TO ABRAM, "LOOK, YAHWEH HAS PREVENTED ME FROM BEARING CHILDREN, SO LAY WITH MY SLAVE-GIRL. MAYBE I CAN BUILD A FAMILY THROUGH HER."

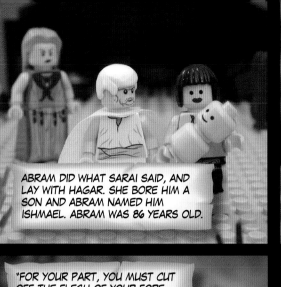

ABRAM DID WHAT SARAI SAID, AND LAY WITH HAGAR. SHE BORE HIM A SON AND ABRAM NAMED HIM ISHMAEL. ABRAM WAS 86 YEARS OLD.

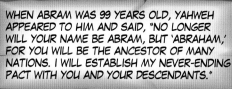

WHEN ABRAM WAS 99 YEARS OLD, YAHWEH APPEARED TO HIM AND SAID, "NO LONGER WILL YOUR NAME BE ABRAM, BUT 'ABRAHAM,' FOR YOU WILL BE THE ANCESTOR OF MANY NATIONS. I WILL ESTABLISH MY NEVER-ENDING PACT WITH YOU AND YOUR DESCENDANTS."

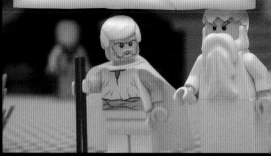

"FOR YOUR PART, YOU MUST CUT OFF THE FLESH OF YOUR FORE-SKINS. THROUGHOUT THE GENER-ATIONS, EVERY MALE AMONG YOU MUST BE CIRCUMCISED ONCE HE IS 8 DAYS OLD, INCLUDING SLAVES BORN IN YOUR HOUSE AND ANY PEOPLE PURCHASED WITH MONEY."

GOD SAID TO ABRAHAM, "YOU SHALL NO LONGER CALL YOUR WIFE SARAI. 'SARAH' WILL BE HER NAME, AND I WILL GIVE YOU A SON THROUGH HER." ABRAHAM FELL ON HIS FACE AND LAUGHED, THINKING, "CAN A SON BE BORN TO A MAN WHO IS 100? CAN SARAH GIVE BIRTH TO A CHILD AT 90?"

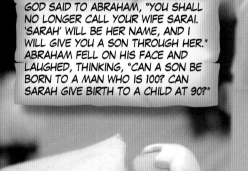

ABRAHAM WAS 99 YEARS OLD WHEN THE FLESH OF HIS FORESKIN WAS CUT OFF.

ISHMAEL WAS 13 YEARS OLD WHEN THE FLESH OF HIS FORESKIN WAS CUT OFF.

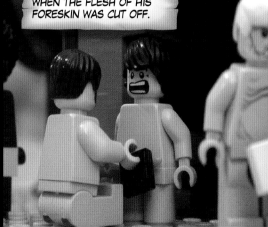

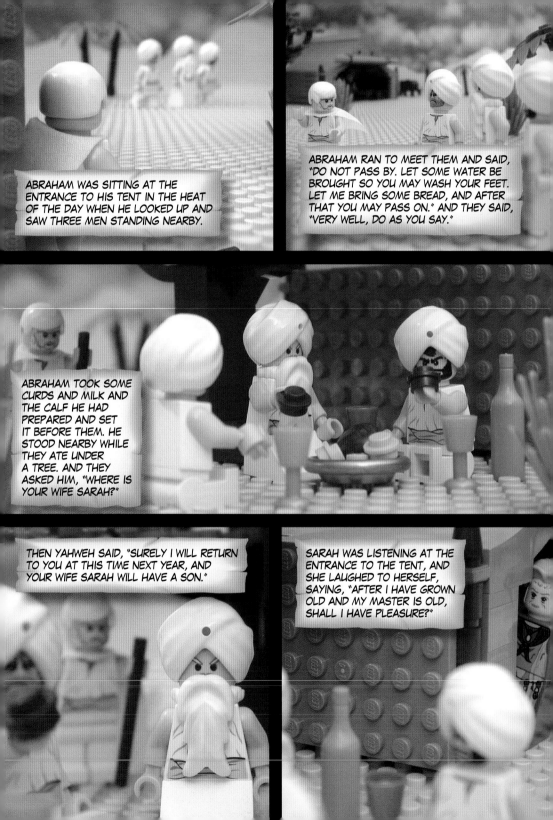

ABRAHAM WAS SITTING AT THE ENTRANCE TO HIS TENT IN THE HEAT OF THE DAY WHEN HE LOOKED UP AND SAW THREE MEN STANDING NEARBY.

ABRAHAM RAN TO MEET THEM AND SAID, "DO NOT PASS BY. LET SOME WATER BE BROUGHT SO YOU MAY WASH YOUR FEET. LET ME BRING SOME BREAD, AND AFTER THAT YOU MAY PASS ON." AND THEY SAID, "VERY WELL, DO AS YOU SAY."

ABRAHAM TOOK SOME CURDS AND MILK AND THE CALF HE HAD PREPARED AND SET IT BEFORE THEM. HE STOOD NEARBY WHILE THEY ATE UNDER A TREE. AND THEY ASKED HIM, "WHERE IS YOUR WIFE SARAH?"

THEN YAHWEH SAID, "SURELY I WILL RETURN TO YOU AT THIS TIME NEXT YEAR, AND YOUR WIFE SARAH WILL HAVE A SON."

SARAH WAS LISTENING AT THE ENTRANCE TO THE TENT, AND SHE LAUGHED TO HERSELF, SAYING, "AFTER I HAVE GROWN OLD AND MY MASTER IS OLD, SHALL I HAVE PLEASURE?"

YAHWEH SAID TO ABRAHAM, "WHY DID SARAH LAUGH? IS ANYTHING TOO AMAZING FOR YAHWEH?"

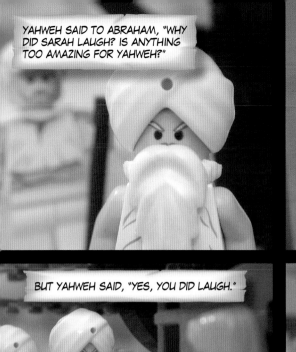

SARAH WAS AFRAID AND LIED, SAYING, "I DIDN'T LAUGH."

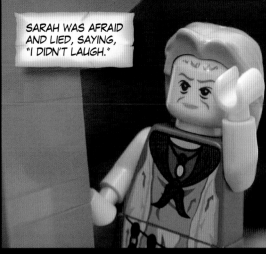

BUT YAHWEH SAID, "YES, YOU DID LAUGH."

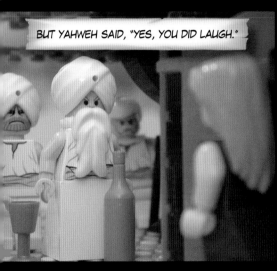

WHEN THE MEN SET OUT FROM THERE, THEY LOOKED TOWARD SODOM. AND YAHWEH SAID, "SHALL I HIDE FROM ABRAHAM WHAT I AM ABOUT TO DO? THE OUTCRY OVER SODOM AND GOMORRAH IS GREAT, AND THEIR SIN IS WEIGHTY."

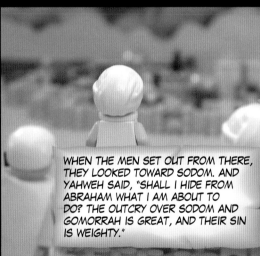

THEN YAHWEH SAID, "I WILL GO DOWN AND SEE IF WHAT THEY HAVE DONE IS TRULY IN ACCORDANCE WITH THE OUTCRY." AND THE MEN TURNED FROM THERE AND WENT TOWARD SODOM, WHILE ABRAHAM REMAINED STANDING BEFORE YAHWEH.

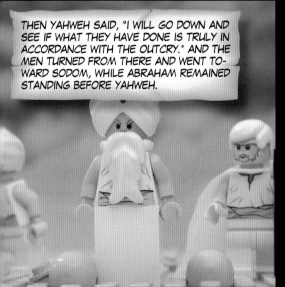

THE TWO ANGELS CAME TO SODOM IN THE EVENING, AND ABRAHAM'S NEPHEW, LOT, WAS SITTING AT THE CITY GATE.

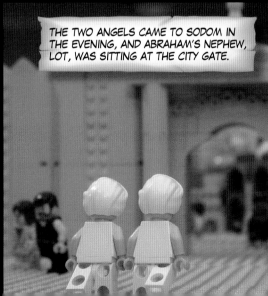

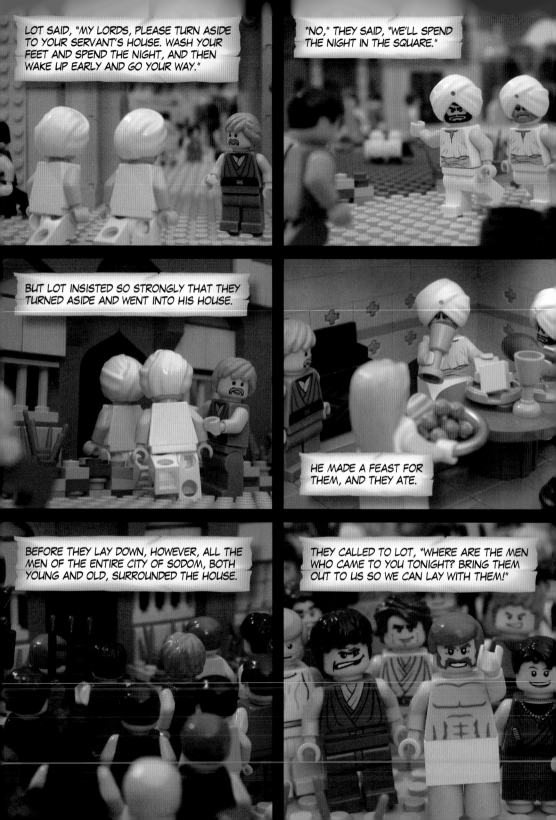

LOT WENT OUTSIDE AND SHUT THE DOOR BEHIND HIM. HE SAID, "NO, MY BROTHERS, DO NOT BE SO WICKED! LOOK, I HAVE TWO VIRGIN DAUGHTERS. LET ME BRING THEM OUT TO YOU, AND YOU MAY DO TO THEM WHATEVER YOU WISH!"

"JUST DON'T DO ANYTHING TO THESE MEN, FOR THEY HAVE COME UNDER THE PROTECTION OF MY ROOF!" SAID LOT. BUT THEY SAID, "STEP ASIDE!"

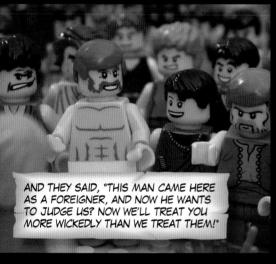

AND THEY SAID, "THIS MAN CAME HERE AS A FOREIGNER, AND NOW HE WANTS TO JUDGE US? NOW WE'LL TREAT YOU MORE WICKEDLY THAN WE TREAT THEM!"

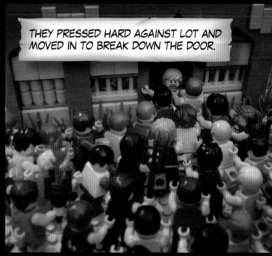

THEY PRESSED HARD AGAINST LOT AND MOVED IN TO BREAK DOWN THE DOOR.

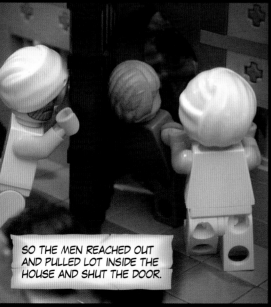

SO THE MEN REACHED OUT AND PULLED LOT INSIDE THE HOUSE AND SHUT THE DOOR.

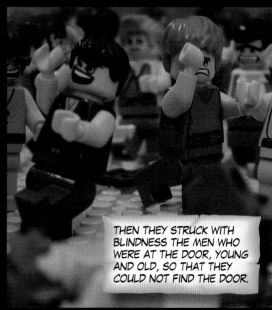

THEN THEY STRUCK WITH BLINDNESS THE MEN WHO WERE AT THE DOOR, YOUNG AND OLD, SO THAT THEY COULD NOT FIND THE DOOR.

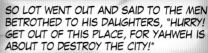

SO LOT WENT OUT AND SAID TO THE MEN BETROTHED TO HIS DAUGHTERS, "HURRY! GET OUT OF THIS PLACE, FOR YAHWEH IS ABOUT TO DESTROY THE CITY!"

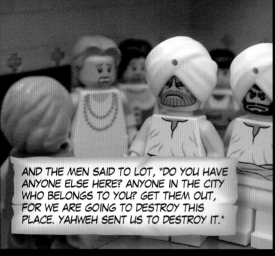

AND THE MEN SAID TO LOT, "DO YOU HAVE ANYONE ELSE HERE? ANYONE IN THE CITY WHO BELONGS TO YOU? GET THEM OUT, FOR WE ARE GOING TO DESTROY THIS PLACE. YAHWEH SENT US TO DESTROY IT."

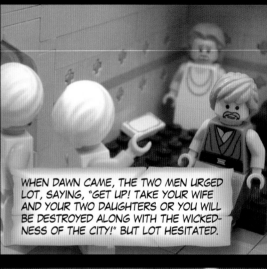

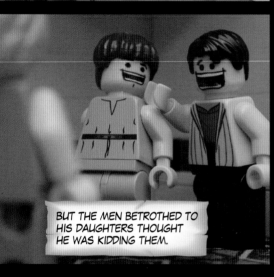

BUT THE MEN BETROTHED TO HIS DAUGHTERS THOUGHT HE WAS KIDDING THEM.

WHEN DAWN CAME, THE TWO MEN URGED LOT, SAYING, "GET UP! TAKE YOUR WIFE AND YOUR TWO DAUGHTERS OR YOU WILL BE DESTROYED ALONG WITH THE WICKEDNESS OF THE CITY!" BUT LOT HESITATED.

SO THE MEN GRABBED THE HANDS OF LOT, HIS WIFE, AND HIS TWO DAUGHTERS, AND TOOK HIM OUT OF THE CITY.

WHEN THEY HAD BROUGHT THEM OUTSIDE, THEY SAID, "FLEE FOR YOUR LIVES! DO NOT LOOK BEHIND YOU OR STOP ANYWHERE IN THE VALLEY. FLEE TO THE MOUNTAINS, OR YOU WILL BE DESTROYED!"

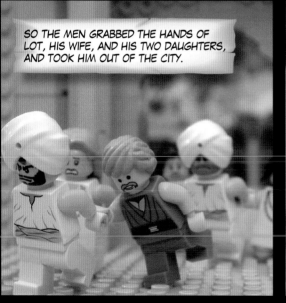

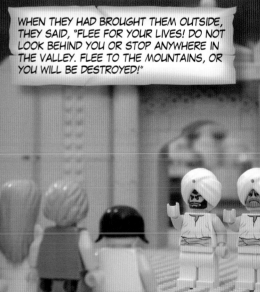

52

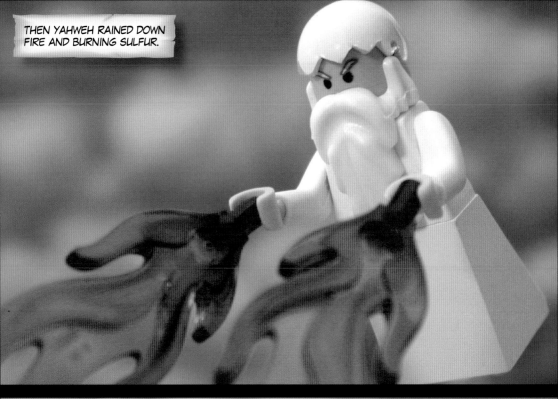

THEN YAHWEH RAINED DOWN FIRE AND BURNING SULFUR.

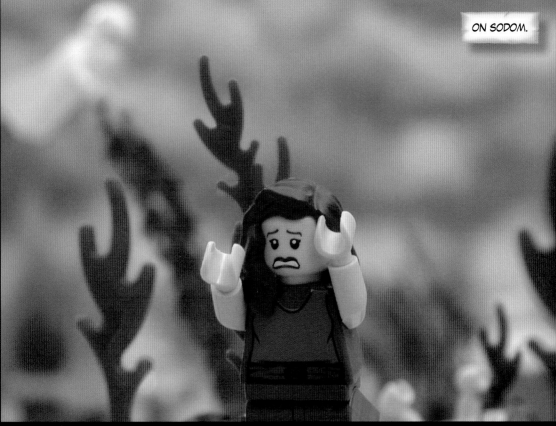

ON SODOM.

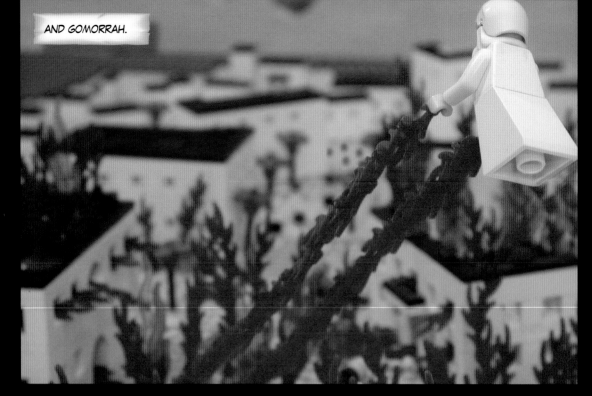

AND GOMORRAH.

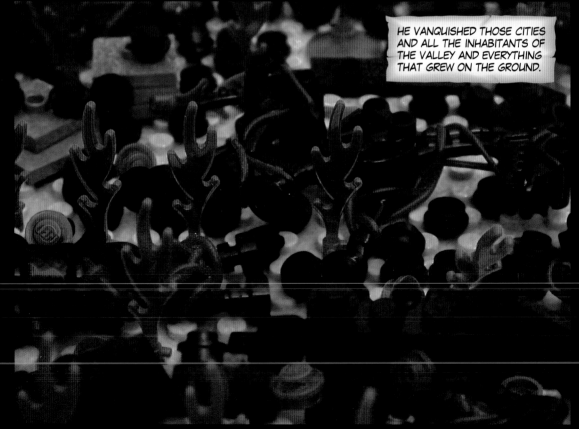

HE VANQUISHED THOSE CITIES AND ALL THE INHABITANTS OF THE VALLEY AND EVERYTHING THAT GREW ON THE GROUND.

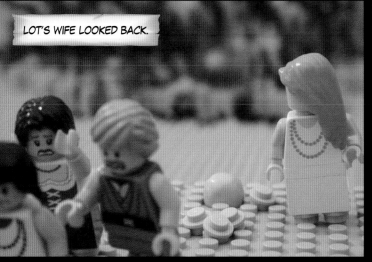

LOT'S WIFE LOOKED BACK.

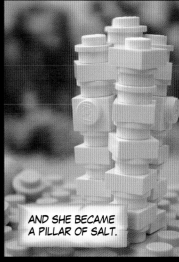

AND SHE BECAME A PILLAR OF SALT.

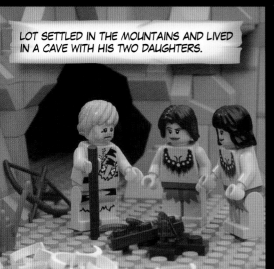

LOT SETTLED IN THE MOUNTAINS AND LIVED IN A CAVE WITH HIS TWO DAUGHTERS.

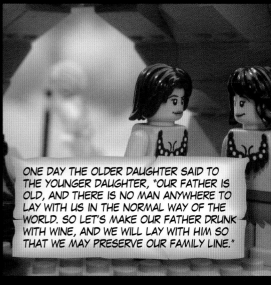

ONE DAY THE OLDER DAUGHTER SAID TO THE YOUNGER DAUGHTER, "OUR FATHER IS OLD, AND THERE IS NO MAN ANYWHERE TO LAY WITH US IN THE NORMAL WAY OF THE WORLD. SO LET'S MAKE OUR FATHER DRUNK WITH WINE, AND WE WILL LAY WITH HIM SO THAT WE MAY PRESERVE OUR FAMILY LINE."

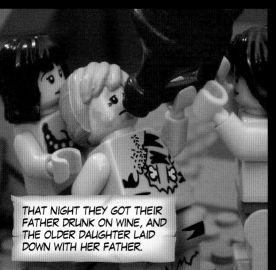

THAT NIGHT THEY GOT THEIR FATHER DRUNK ON WINE, AND THE OLDER DAUGHTER LAID DOWN WITH HER FATHER.

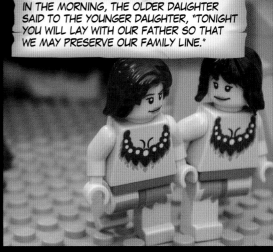

IN THE MORNING, THE OLDER DAUGHTER SAID TO THE YOUNGER DAUGHTER, "TONIGHT YOU WILL LAY WITH OUR FATHER SO THAT WE MAY PRESERVE OUR FAMILY LINE."

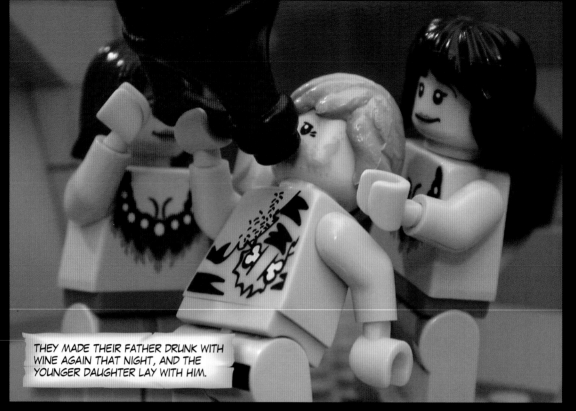

THEY MADE THEIR FATHER DRUNK WITH WINE AGAIN THAT NIGHT, AND THE YOUNGER DAUGHTER LAY WITH HIM.

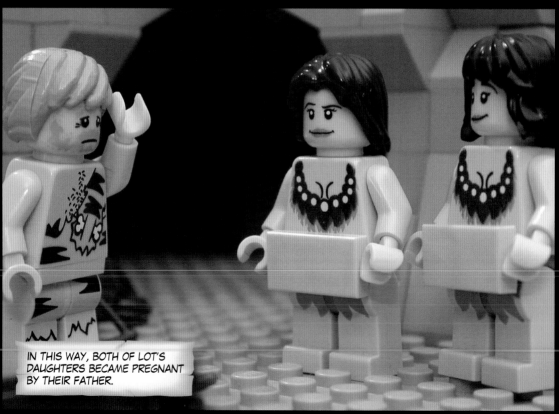

IN THIS WAY, BOTH OF LOT'S DAUGHTERS BECAME PREGNANT BY THEIR FATHER.

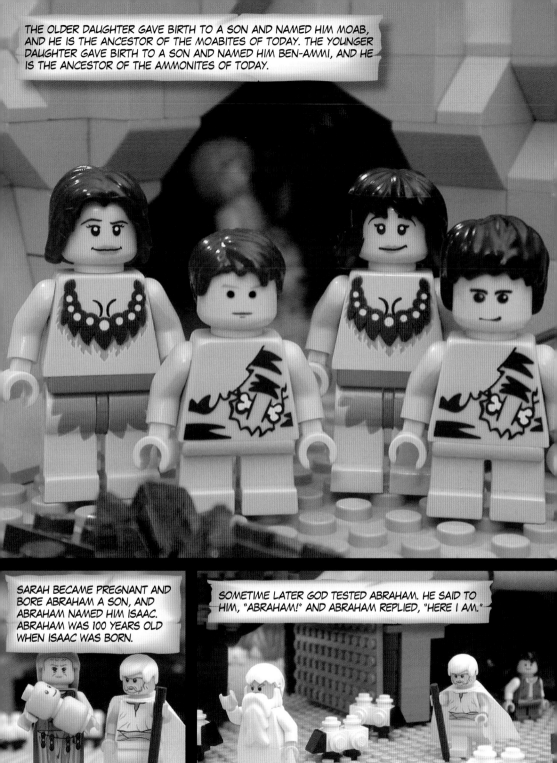

THE OLDER DAUGHTER GAVE BIRTH TO A SON AND NAMED HIM MOAB, AND HE IS THE ANCESTOR OF THE MOABITES OF TODAY. THE YOUNGER DAUGHTER GAVE BIRTH TO A SON AND NAMED HIM BEN-AMMI, AND HE IS THE ANCESTOR OF THE AMMONITES OF TODAY.

SARAH BECAME PREGNANT AND BORE ABRAHAM A SON, AND ABRAHAM NAMED HIM ISAAC. ABRAHAM WAS 100 YEARS OLD WHEN ISAAC WAS BORN.

SOMETIME LATER GOD TESTED ABRAHAM. HE SAID TO HIM, "ABRAHAM!" AND ABRAHAM REPLIED, "HERE I AM."

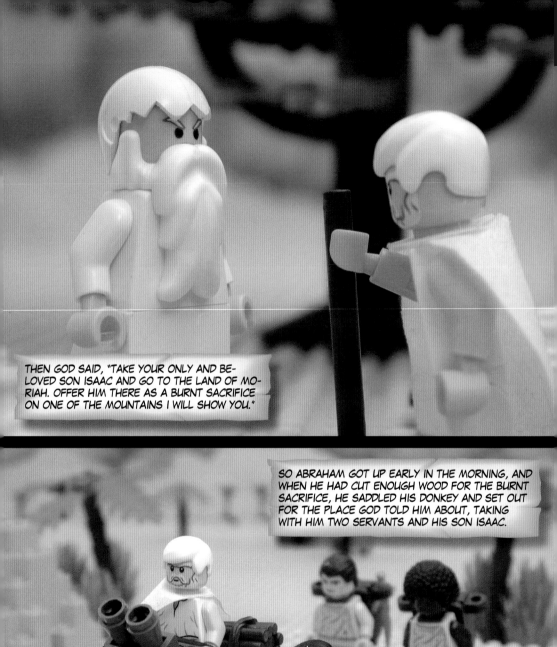

THEN GOD SAID, "TAKE YOUR ONLY AND BE-LOVED SON ISAAC AND GO TO THE LAND OF MO-RIAH. OFFER HIM THERE AS A BURNT SACRIFICE ON ONE OF THE MOUNTAINS I WILL SHOW YOU."

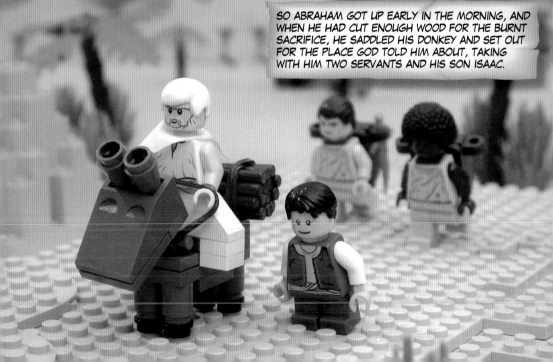

SO ABRAHAM GOT UP EARLY IN THE MORNING, AND WHEN HE HAD CUT ENOUGH WOOD FOR THE BURNT SACRIFICE, HE SADDLED HIS DONKEY AND SET OUT FOR THE PLACE GOD TOLD HIM ABOUT, TAKING WITH HIM TWO SERVANTS AND HIS SON ISAAC.

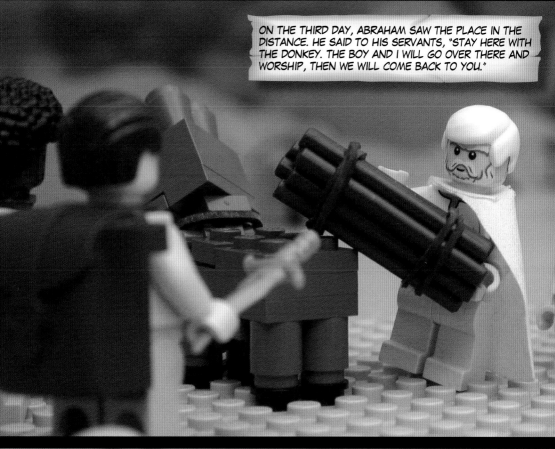

ON THE THIRD DAY, ABRAHAM SAW THE PLACE IN THE DISTANCE. HE SAID TO HIS SERVANTS, "STAY HERE WITH THE DONKEY. THE BOY AND I WILL GO OVER THERE AND WORSHIP, THEN WE WILL COME BACK TO YOU."

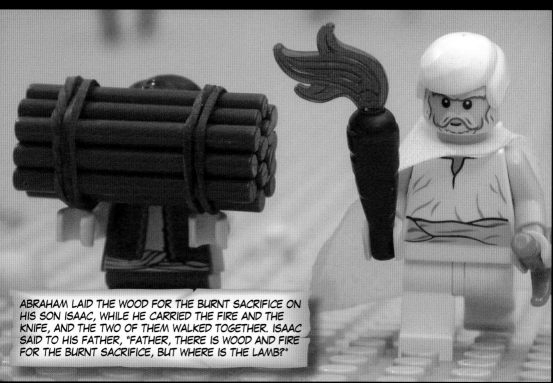

ABRAHAM LAID THE WOOD FOR THE BURNT SACRIFICE ON HIS SON ISAAC, WHILE HE CARRIED THE FIRE AND THE KNIFE, AND THE TWO OF THEM WALKED TOGETHER. ISAAC SAID TO HIS FATHER, "FATHER, THERE IS WOOD AND FIRE FOR THE BURNT SACRIFICE, BUT WHERE IS THE LAMB?"

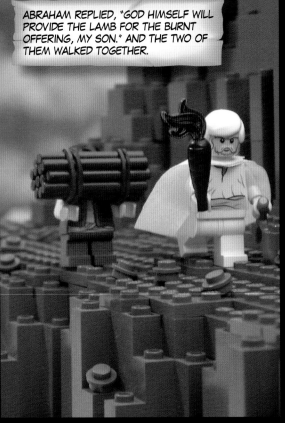

ABRAHAM REPLIED, "GOD HIMSELF WILL PROVIDE THE LAMB FOR THE BURNT OFFERING, MY SON." AND THE TWO OF THEM WALKED TOGETHER.

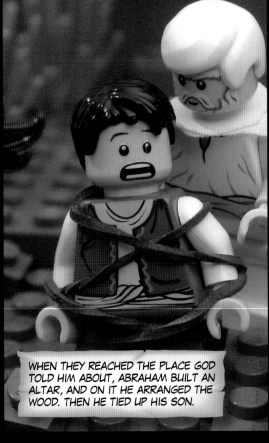

WHEN THEY REACHED THE PLACE GOD TOLD HIM ABOUT, ABRAHAM BUILT AN ALTAR, AND ON IT HE ARRANGED THE WOOD. THEN HE TIED UP HIS SON.

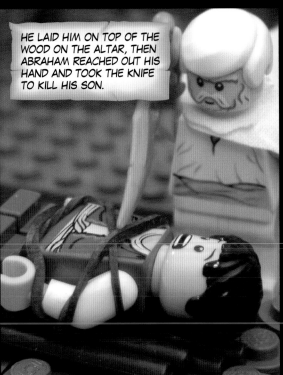

HE LAID HIM ON TOP OF THE WOOD ON THE ALTAR, THEN ABRAHAM REACHED OUT HIS HAND AND TOOK THE KNIFE TO KILL HIS SON.

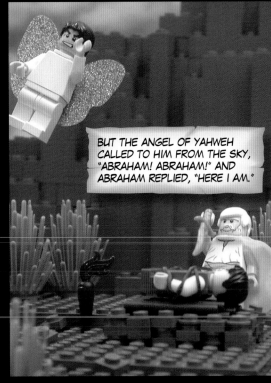

BUT THE ANGEL OF YAHWEH CALLED TO HIM FROM THE SKY, "ABRAHAM! ABRAHAM!" AND ABRAHAM REPLIED, "HERE I AM."

60

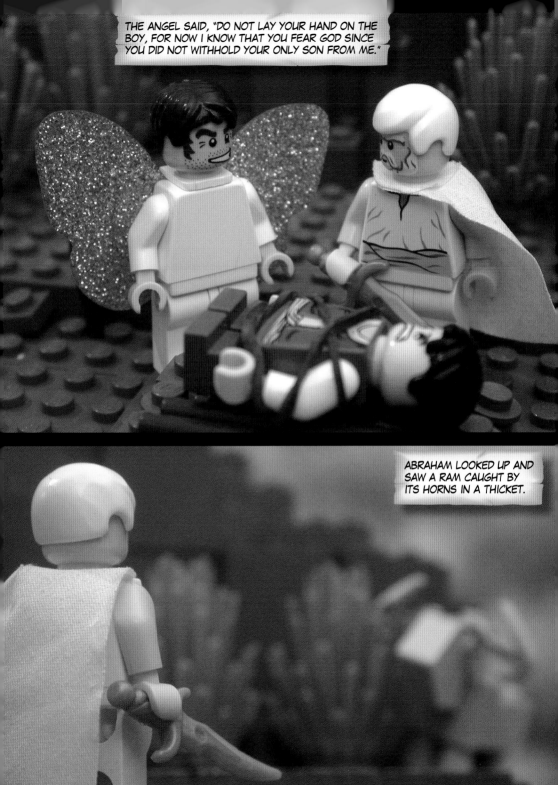

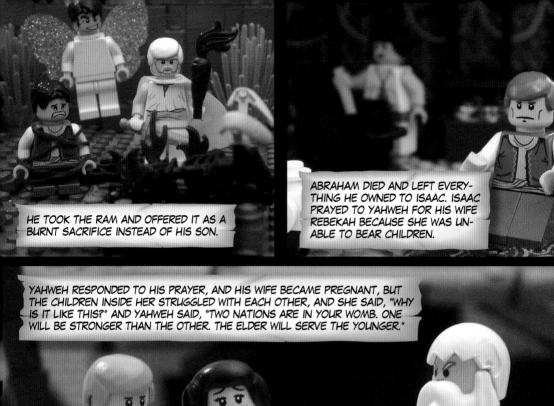

HE TOOK THE RAM AND OFFERED IT AS A BURNT SACRIFICE INSTEAD OF HIS SON.

ABRAHAM DIED AND LEFT EVERY-THING HE OWNED TO ISAAC. ISAAC PRAYED TO YAHWEH FOR HIS WIFE REBEKAH BECAUSE SHE WAS UN-ABLE TO BEAR CHILDREN.

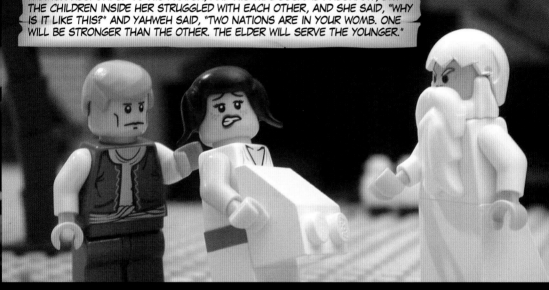

YAHWEH RESPONDED TO HIS PRAYER, AND HIS WIFE BECAME PREGNANT, BUT THE CHILDREN INSIDE HER STRUGGLED WITH EACH OTHER, AND SHE SAID, "WHY IS IT LIKE THIS?" AND YAHWEH SAID, "TWO NATIONS ARE IN YOUR WOMB. ONE WILL BE STRONGER THAN THE OTHER. THE ELDER WILL SERVE THE YOUNGER."

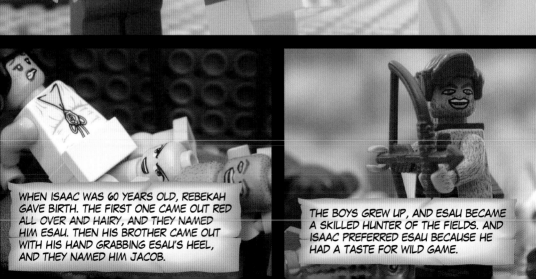

WHEN ISAAC WAS 60 YEARS OLD, REBEKAH GAVE BIRTH. THE FIRST ONE CAME OUT RED ALL OVER AND HAIRY, AND THEY NAMED HIM ESAU. THEN HIS BROTHER CAME OUT WITH HIS HAND GRABBING ESAU'S HEEL, AND THEY NAMED HIM JACOB.

THE BOYS GREW UP, AND ESAU BECAME A SKILLED HUNTER OF THE FIELDS. AND ISAAC PREFERRED ESAU BECAUSE HE HAD A TASTE FOR WILD GAME.

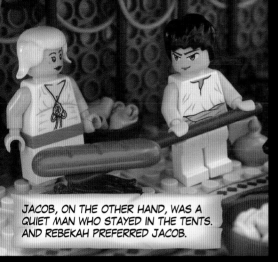

JACOB, ON THE OTHER HAND, WAS A QUIET MAN WHO STAYED IN THE TENTS. AND REBEKAH PREFERRED JACOB.

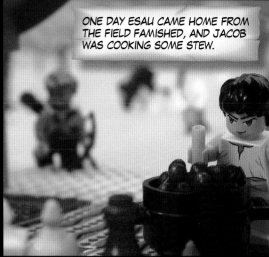

ONE DAY ESAU CAME HOME FROM THE FIELD FAMISHED, AND JACOB WAS COOKING SOME STEW.

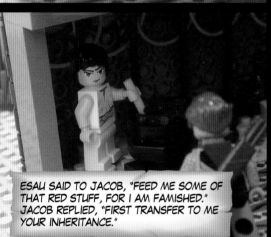

ESAU SAID TO JACOB, "FEED ME SOME OF THAT RED STUFF, FOR I AM FAMISHED." JACOB REPLIED, "FIRST TRANSFER TO ME YOUR INHERITANCE."

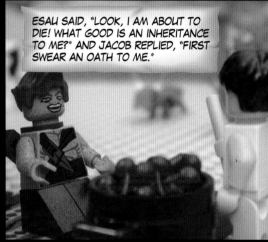

ESAU SAID, "LOOK, I AM ABOUT TO DIE! WHAT GOOD IS AN INHERITANCE TO ME?" AND JACOB REPLIED, "FIRST SWEAR AN OATH TO ME."

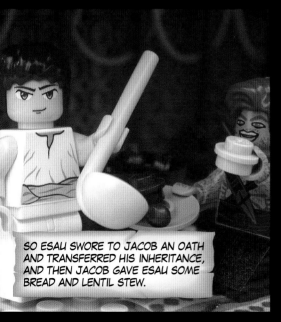

SO ESAU SWORE TO JACOB AN OATH AND TRANSFERRED HIS INHERITANCE, AND THEN JACOB GAVE ESAU SOME BREAD AND LENTIL STEW.

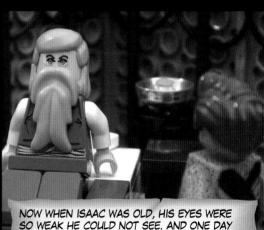

NOW WHEN ISAAC WAS OLD, HIS EYES WERE SO WEAK HE COULD NOT SEE. AND ONE DAY HE CALLED TO HIS ELDER SON ESAU AND SAID, "MY SON, GO OUT IN THE FIELD AND HUNT SOME GAME FOR ME, AND PREPARE THE KIND OF TASTY DISH I LIKE SO I CAN GIVE YOU MY SPECIAL BLESSING BEFORE I DIE."

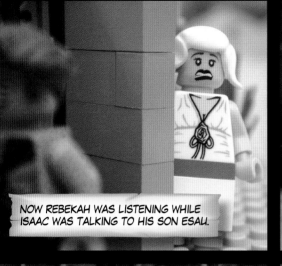

NOW REBEKAH WAS LISTENING WHILE ISAAC WAS TALKING TO HIS SON ESAU.

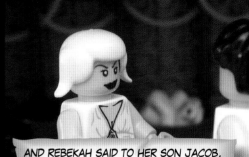
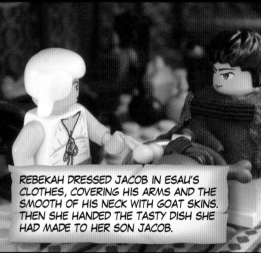

AND REBEKAH SAID TO HER SON JACOB, "GO TO THE FLOCK AND BRING ME TWO YOUNG GOATS, SO THAT I CAN MAKE THE KIND OF TASTY DISH YOUR FATHER LIKES. THEN TAKE IT TO YOUR FATHER, SO THAT HE MAY BLESS YOU BEFORE HE DIES."

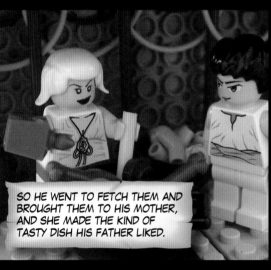

SO HE WENT TO FETCH THEM AND BROUGHT THEM TO HIS MOTHER, AND SHE MADE THE KIND OF TASTY DISH HIS FATHER LIKED.

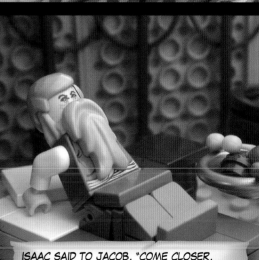

REBEKAH DRESSED JACOB IN ESAU'S CLOTHES, COVERING HIS ARMS AND THE SMOOTH OF HIS NECK WITH GOAT SKINS. THEN SHE HANDED THE TASTY DISH SHE HAD MADE TO HER SON JACOB.

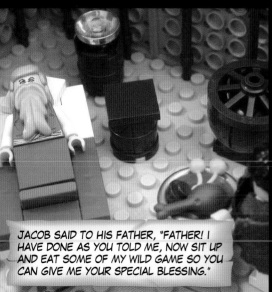

JACOB SAID TO HIS FATHER, "FATHER! I HAVE DONE AS YOU TOLD ME, NOW SIT UP AND EAT SOME OF MY WILD GAME SO YOU CAN GIVE ME YOUR SPECIAL BLESSING."

ISAAC SAID TO JACOB, "COME CLOSER, SON, SO THAT I CAN FEEL YOU AND BE SURE WHETHER YOU REALLY ARE MY SON ESAU."

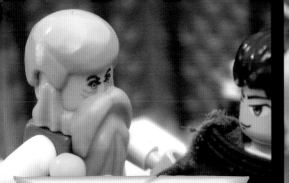

JACOB WENT CLOSER TO HIS FATHER ISAAC, WHO FELT HIM AND SAID, "THE VOICE IS JACOB'S BUT THE ARMS ARE ESAU'S!"

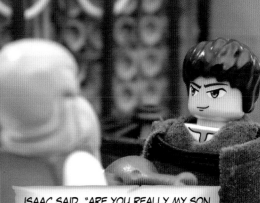

ISAAC SAID, "ARE YOU REALLY MY SON ESAU?" AND JACOB REPLIED, "I AM."

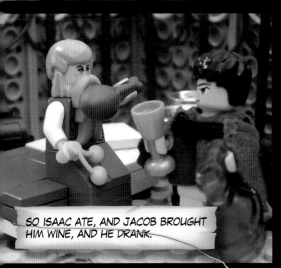

SO ISAAC ATE, AND JACOB BROUGHT HIM WINE, AND HE DRANK.

THEN HE BLESSED HIM, SAYING, "MAY GOD GIVE YOU THE EARTH'S BOUNTY! MAY NATIONS SERVE YOU AND BOW DOWN TO YOU. RULE OVER YOUR BROTHERS. MAY THOSE WHO CURSE YOU BE CURSED AND THOSE WHO BLESS YOU BE BLESSED!"

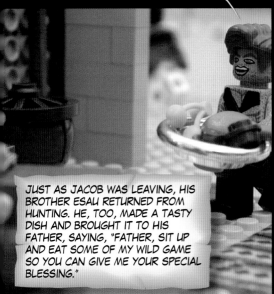

JUST AS JACOB WAS LEAVING, HIS BROTHER ESAU RETURNED FROM HUNTING. HE, TOO, MADE A TASTY DISH AND BROUGHT IT TO HIS FATHER, SAYING, "FATHER, SIT UP AND EAT SOME OF MY WILD GAME SO YOU CAN GIVE ME YOUR SPECIAL BLESSING."

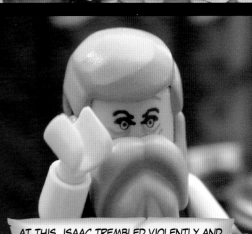

AT THIS, ISAAC TREMBLED VIOLENTLY AND SAID, "WHO WAS IT, THEN, THAT JUST BROUGHT ME WILD GAME? I ATE IT JUST BEFORE YOU RETURNED AND BLESSED HIM. AND NOW BLESSED HE WILL REMAIN!"

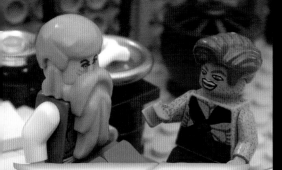

HEARING HIS FATHER'S WORDS, ESAU CRIED OUT LOUDLY AND BITTERLY AND SAID TO HIS FATHER, "FATHER, BLESS ME, TOO! HAVE YOU NOT KEPT A BLESSING FOR ME?"

ISAAC REMAINED SILENT, AND ESAU BEGAN TO WEEP ALOUD. THEN HIS FATHER ISAAC SAID, "INDEED, YOU WILL LIVE FAR FROM THE BOUNTY OF THE EARTH. YOU WILL LIVE BY YOUR SWORD AND BE A SERVANT TO YOUR BROTHER."

WHEN ESAU WAS FORTY YEARS OLD, HE MARRIED JUDITH DAUGHTER OF BEERI THE HITTITE, AND BASEMETH DAUGHTER OF ELON THE HITTITE.

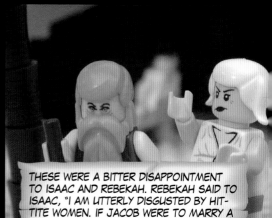

THESE WERE A BITTER DISAPPOINTMENT TO ISAAC AND REBEKAH. REBEKAH SAID TO ISAAC, "I AM UTTERLY DISGUSTED BY HITTITE WOMEN. IF JACOB WERE TO MARRY A HITTITE WOMAN, WHY EVEN GO ON LIVING?"

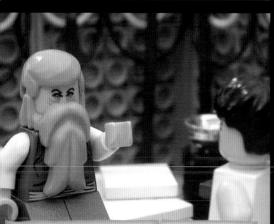

SO ISAAC SUMMONED JACOB AND COMMANDED HIM, SAYING, "YOU MUST NOT MARRY ONE OF THE CANAANITE WOMEN! LEAVE IMMEDIATELY FOR PADDAN-ARAM AND ACQUIRE AS A WIFE ONE OF YOUR UNCLE LABAN'S DAUGHTERS."

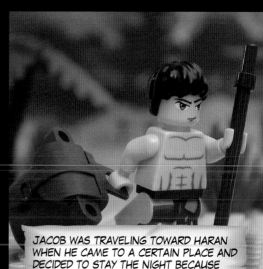

JACOB WAS TRAVELING TOWARD HARAN WHEN HE CAME TO A CERTAIN PLACE AND DECIDED TO STAY THE NIGHT BECAUSE THE SUN WAS GOING DOWN.

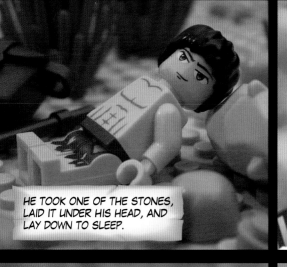

HE TOOK ONE OF THE STONES, LAID IT UNDER HIS HEAD, AND LAY DOWN TO SLEEP.

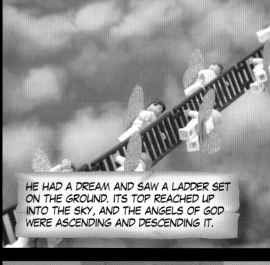

HE HAD A DREAM AND SAW A LADDER SET ON THE GROUND. ITS TOP REACHED UP INTO THE SKY, AND THE ANGELS OF GOD WERE ASCENDING AND DESCENDING IT.

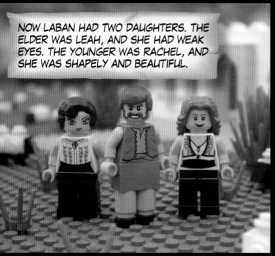

NOW LABAN HAD TWO DAUGHTERS. THE ELDER WAS LEAH, AND SHE HAD WEAK EYES. THE YOUNGER WAS RACHEL, AND SHE WAS SHAPELY AND BEAUTIFUL.

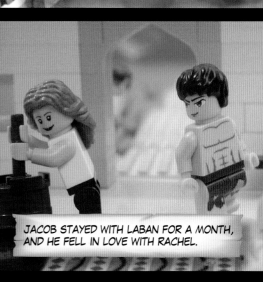

JACOB STAYED WITH LABAN FOR A MONTH, AND HE FELL IN LOVE WITH RACHEL.

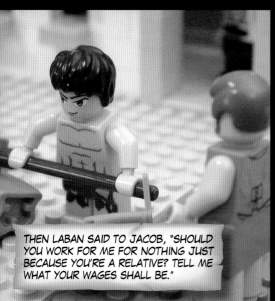

THEN LABAN SAID TO JACOB, "SHOULD YOU WORK FOR ME FOR NOTHING JUST BECAUSE YOU'RE A RELATIVE? TELL ME WHAT YOUR WAGES SHALL BE."

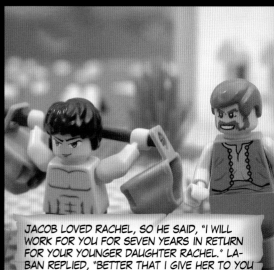

JACOB LOVED RACHEL, SO HE SAID, "I WILL WORK FOR YOU FOR SEVEN YEARS IN RETURN FOR YOUR YOUNGER DAUGHTER RACHEL." LABAN REPLIED, "BETTER THAT I GIVE HER TO YOU THAN SOME OTHER MAN, SO STAY WITH ME."

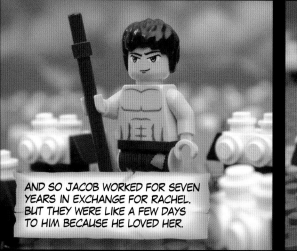

AND SO JACOB WORKED FOR SEVEN YEARS IN EXCHANGE FOR RACHEL. BUT THEY WERE LIKE A FEW DAYS TO HIM BECAUSE HE LOVED HER.

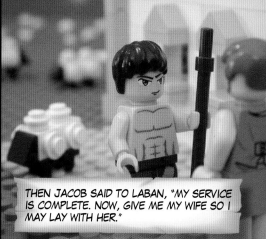

THEN JACOB SAID TO LABAN, "MY SERVICE IS COMPLETE. NOW, GIVE ME MY WIFE SO I MAY LAY WITH HER."

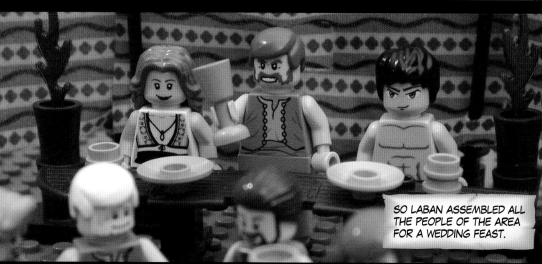

SO LABAN ASSEMBLED ALL THE PEOPLE OF THE AREA FOR A WEDDING FEAST.

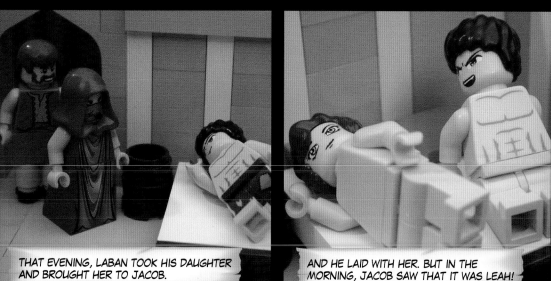

THAT EVENING, LABAN TOOK HIS DAUGHTER AND BROUGHT HER TO JACOB.

AND HE LAID WITH HER. BUT IN THE MORNING, JACOB SAW THAT IT WAS LEAH!

68

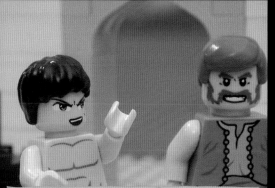

AND HE SAID TO LABAN, "WHAT HAVE YOU DONE TO ME? DID I NOT WORK FOR YOU IN RETURN FOR RACHEL? WHY DID YOU DECEIVE ME?"

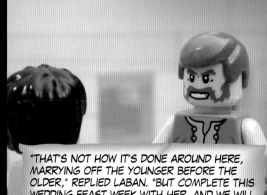

"THAT'S NOT HOW IT'S DONE AROUND HERE, MARRYING OFF THE YOUNGER BEFORE THE OLDER," REPLIED LABAN. "BUT COMPLETE THIS WEDDING FEAST WEEK WITH HER, AND WE WILL GIVE YOU THE OTHER GIRL AS WELL - IN EXCHANGE FOR SEVEN MORE YEARS OF WORK."

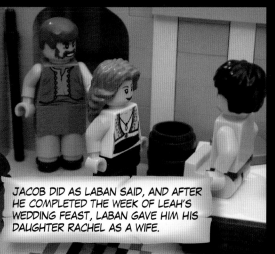

JACOB DID AS LABAN SAID, AND AFTER HE COMPLETED THE WEEK OF LEAH'S WEDDING FEAST, LABAN GAVE HIM HIS DAUGHTER RACHEL AS A WIFE.

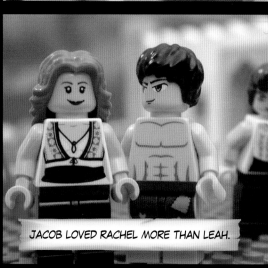

JACOB LOVED RACHEL MORE THAN LEAH.

AND HE WORKED FOR LABAN ANOTHER SEVEN YEARS.

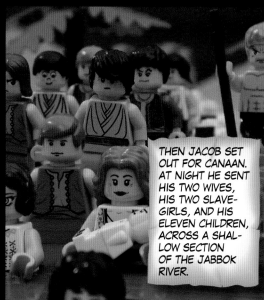

THEN JACOB SET OUT FOR CANAAN. AT NIGHT HE SENT HIS TWO WIVES, HIS TWO SLAVE-GIRLS, AND HIS ELEVEN CHILDREN, ACROSS A SHALLOW SECTION OF THE JABBOK RIVER.

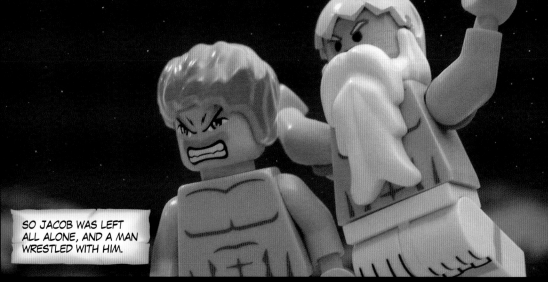

SO JACOB WAS LEFT ALL ALONE, AND A MAN WRESTLED WITH HIM.

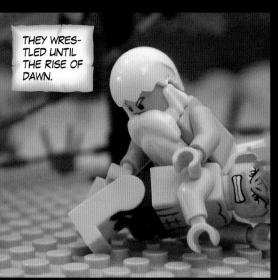

THEY WRES-TLED UNTIL THE RISE OF DAWN.

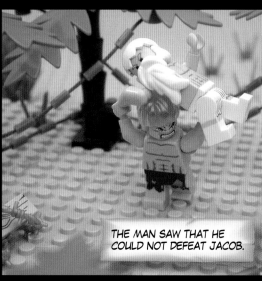

THE MAN SAW THAT HE COULD NOT DEFEAT JACOB.

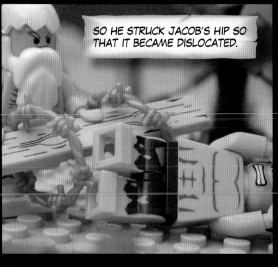

SO HE STRUCK JACOB'S HIP SO THAT IT BECAME DISLOCATED.

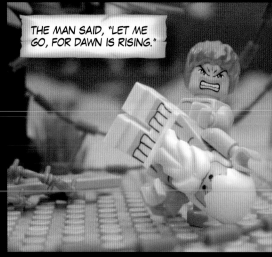

THE MAN SAID, "LET ME GO, FOR DAWN IS RISING."

JACOB SAID, "I WILL NOT LET YOU GO UNLESS YOU BLESS ME." THE MAN SAID TO HIM, "WHAT IS YOUR NAME?" AND HE SAID, "JACOB."

THE MAN SAID, "YOUR NAME WILL NO LONGER BE CALLED JACOB, BUT 'ISRAEL,' FOR YOU HAVE WRESTLED WITH GOD AND MEN, AND YOU HAVE PREVAILED."

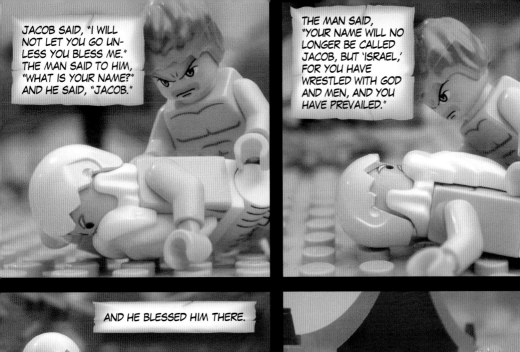

AND HE BLESSED HIM THERE.

JACOB ARRIVED SAFELY AT SHECHEM IN CANAAN AND ESTABLISHED CAMP OUTSIDE THE CITY.

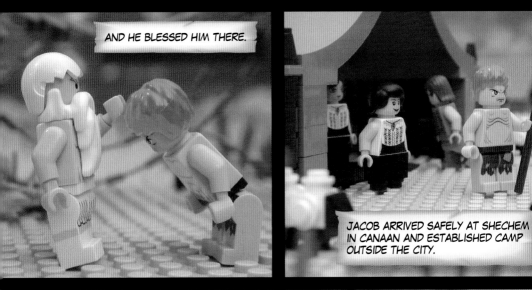

NOW DINAH, THE DAUGHTER LEAH BORE TO JACOB, WENT OUT TO MEET THE YOUNG WOMEN OF THE LAND.

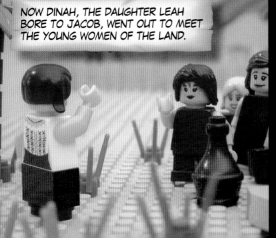

AND SHECHEM, THE PRINCE OF THE LAND, SON OF HAMOR THE HIVITE, SAW HER.

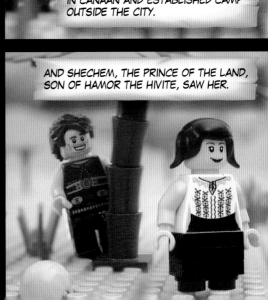

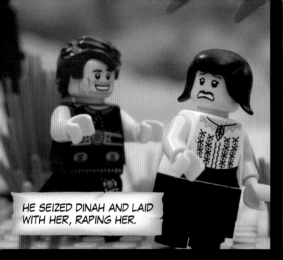

HE SEIZED DINAH AND LAID WITH HER, RAPING HER.

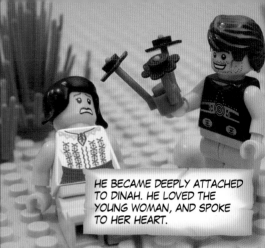

HE BECAME DEEPLY ATTACHED TO DINAH. HE LOVED THE YOUNG WOMAN, AND SPOKE TO HER HEART.

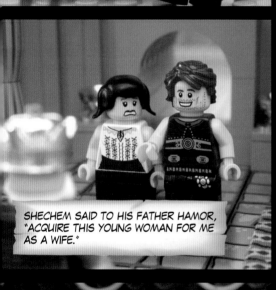

SHECHEM SAID TO HIS FATHER HAMOR, "ACQUIRE THIS YOUNG WOMAN FOR ME AS A WIFE."

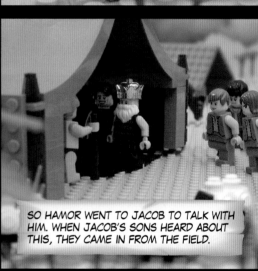

SO HAMOR WENT TO JACOB TO TALK WITH HIM. WHEN JACOB'S SONS HEARD ABOUT THIS, THEY CAME IN FROM THE FIELD.

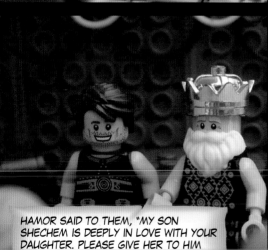

HAMOR SAID TO THEM, "MY SON SHECHEM IS DEEPLY IN LOVE WITH YOUR DAUGHTER. PLEASE GIVE HER TO HIM AS A WIFE. INTERMARRY WITH US. GIVE YOUR DAUGHTERS TO US, AND TAKE OUR DAUGHTERS FOR YOURSELVES."

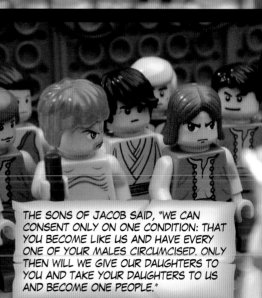

THE SONS OF JACOB SAID, "WE CAN CONSENT ONLY ON ONE CONDITION: THAT YOU BECOME LIKE US AND HAVE EVERY ONE OF YOUR MALES CIRCUMCISED. ONLY THEN WILL WE GIVE OUR DAUGHTERS TO YOU AND TAKE YOUR DAUGHTERS TO US AND BECOME ONE PEOPLE."

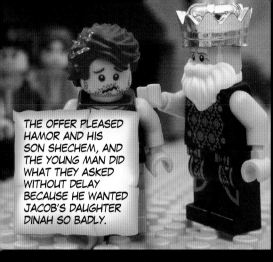

THE OFFER PLEASED HAMOR AND HIS SON SHECHEM, AND THE YOUNG MAN DID WHAT THEY ASKED WITHOUT DELAY BECAUSE HE WANTED JACOB'S DAUGHTER DINAH SO BADLY.

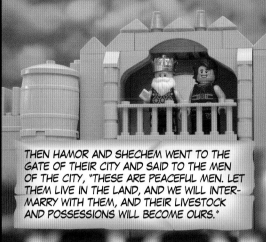

THEN HAMOR AND SHECHEM WENT TO THE GATE OF THEIR CITY AND SAID TO THE MEN OF THE CITY, "THESE ARE PEACEFUL MEN. LET THEM LIVE IN THE LAND, AND WE WILL INTER-MARRY WITH THEM, AND THEIR LIVESTOCK AND POSSESSIONS WILL BECOME OURS."

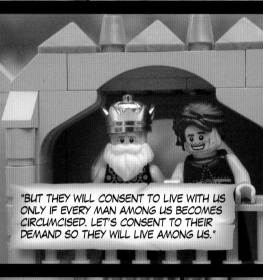

"BUT THEY WILL CONSENT TO LIVE WITH US ONLY IF EVERY MAN AMONG US BECOMES CIRCUMCISED. LET'S CONSENT TO THEIR DEMAND SO THEY WILL LIVE AMONG US."

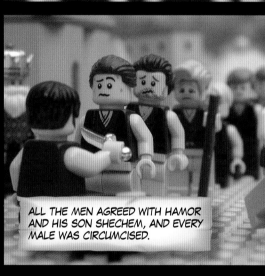

ALL THE MEN AGREED WITH HAMOR AND HIS SON SHECHEM, AND EVERY MALE WAS CIRCUMCISED.

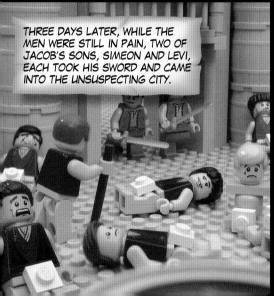

THREE DAYS LATER, WHILE THE MEN WERE STILL IN PAIN, TWO OF JACOB'S SONS, SIMEON AND LEVI, EACH TOOK HIS SWORD AND CAME INTO THE UNSUSPECTING CITY.

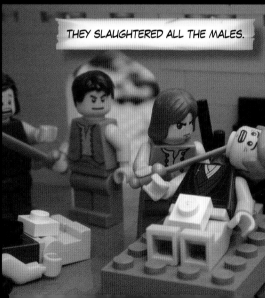

THEY SLAUGHTERED ALL THE MALES.

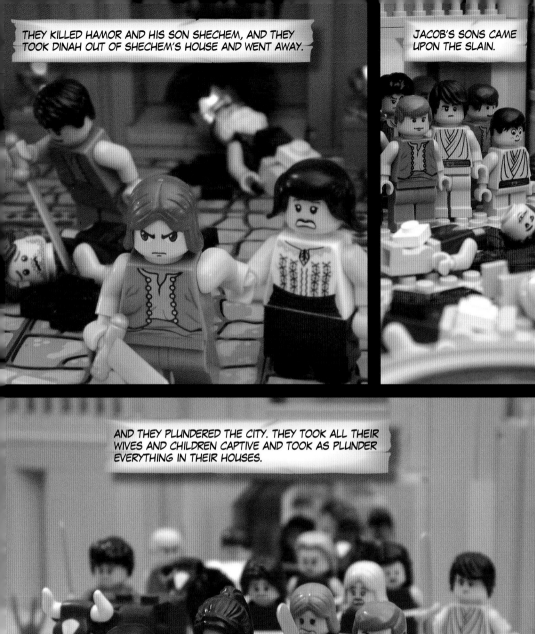

NOW ISRAEL LOVED JOSEPH MORE THAN ANY OF HIS OTHER SONS BECAUSE HE WAS THE SON OF HIS OLD AGE, AND HE MADE HIM A COAT OF MANY COLORS.

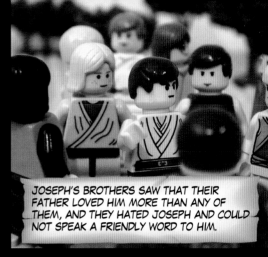

JOSEPH'S BROTHERS SAW THAT THEIR FATHER LOVED HIM MORE THAN ANY OF THEM, AND THEY HATED JOSEPH AND COULD NOT SPEAK A FRIENDLY WORD TO HIM.

NOW ISRAEL SAID TO JOSEPH, "YOUR BROTHERS ARE GRAZING THE FLOCK AT SHECHEM. GO AND SEE IF ALL IS WELL WITH YOUR BROTHERS AND THE FLOCK, AND THEN BRING ME WORD."

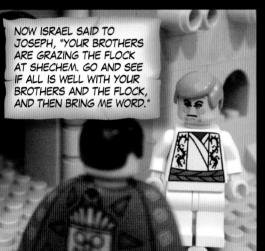

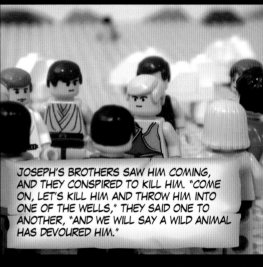

JOSEPH'S BROTHERS SAW HIM COMING, AND THEY CONSPIRED TO KILL HIM. "COME ON, LET'S KILL HIM AND THROW HIM INTO ONE OF THE WELLS," THEY SAID ONE TO ANOTHER, "AND WE WILL SAY A WILD ANIMAL HAS DEVOURED HIM."

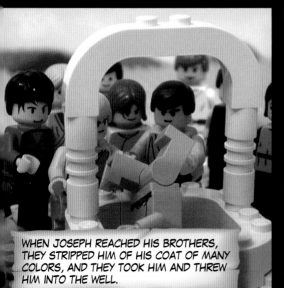

WHEN JOSEPH REACHED HIS BROTHERS, THEY STRIPPED HIM OF HIS COAT OF MANY COLORS, AND THEY TOOK HIM AND THREW HIM INTO THE WELL.

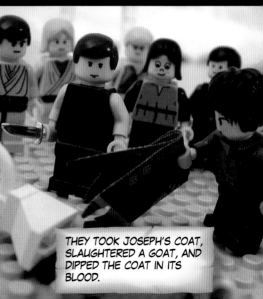

THEY TOOK JOSEPH'S COAT, SLAUGHTERED A GOAT, AND DIPPED THE COAT IN ITS BLOOD.

THEY SENT THE COAT OF MANY COLORS TO THEIR FATHER. HE RECOGNIZED IT AND SAID, "A WILD ANIMAL HAS DEVOURED HIM! JOSEPH IS SURELY TORN TO PIECES!"

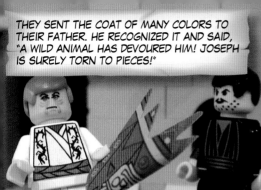

NOW SOME MIDIANITE MERCHANTS WERE PASSING BY, AND THEY PULLED JOSEPH UP OUT OF THE WELL.

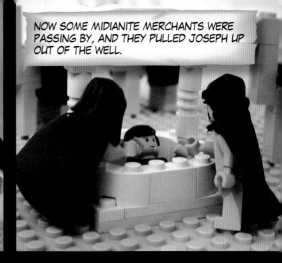

THEY SOLD JOSEPH TO THE ISHMAELITES FOR TWENTY PIECES OF SILVER, AND THE ISHMAELITES BROUGHT JOSEPH TO EGYPT.

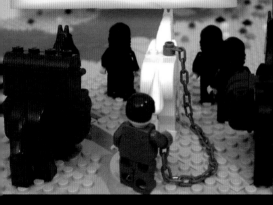

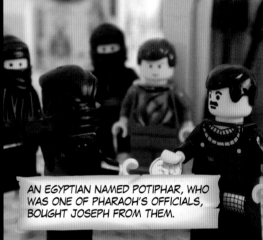

AN EGYPTIAN NAMED POTIPHAR, WHO WAS ONE OF PHARAOH'S OFFICIALS, BOUGHT JOSEPH FROM THEM.

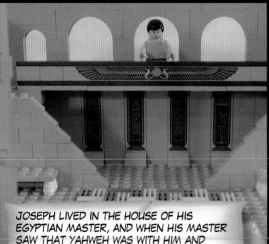

JOSEPH LIVED IN THE HOUSE OF HIS EGYPTIAN MASTER, AND WHEN HIS MASTER SAW THAT YAHWEH WAS WITH HIM AND HOW YAHWEH MADE ALL HIS UNDERTAKINGS SUCCESSFUL, HE PUT HIM IN CHARGE OF HIS HOUSEHOLD.

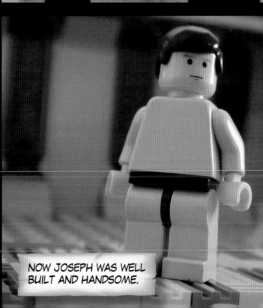

NOW JOSEPH WAS WELL BUILT AND HANDSOME.

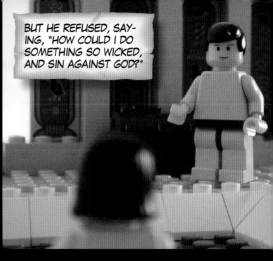

BUT HE REFUSED, SAYING, "HOW COULD I DO SOMETHING SO WICKED, AND SIN AGAINST GOD?"

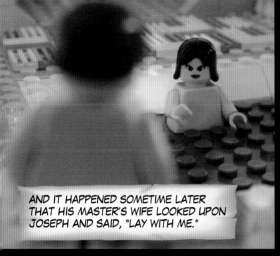

AND IT HAPPENED SOMETIME LATER THAT HIS MASTER'S WIFE LOOKED UPON JOSEPH AND SAID, "LAY WITH ME."

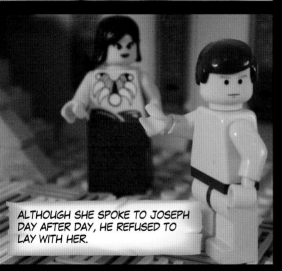

ALTHOUGH SHE SPOKE TO JOSEPH DAY AFTER DAY, HE REFUSED TO LAY WITH HER.

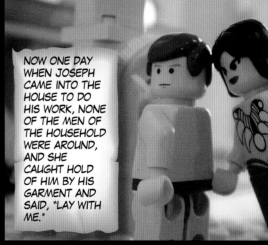

NOW ONE DAY WHEN JOSEPH CAME INTO THE HOUSE TO DO HIS WORK, NONE OF THE MEN OF THE HOUSEHOLD WERE AROUND, AND SHE CAUGHT HOLD OF HIM BY HIS GARMENT AND SAID, "LAY WITH ME."

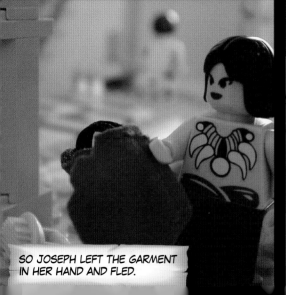

SO JOSEPH LEFT THE GARMENT IN HER HAND AND FLED.

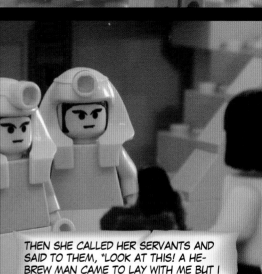

THEN SHE CALLED HER SERVANTS AND SAID TO THEM, "LOOK AT THIS! A HEBREW MAN CAME TO LAY WITH ME BUT I SCREAMED, AND HE LEFT HIS GARMENT BESIDE ME AND RAN OUT OF THE HOUSE."

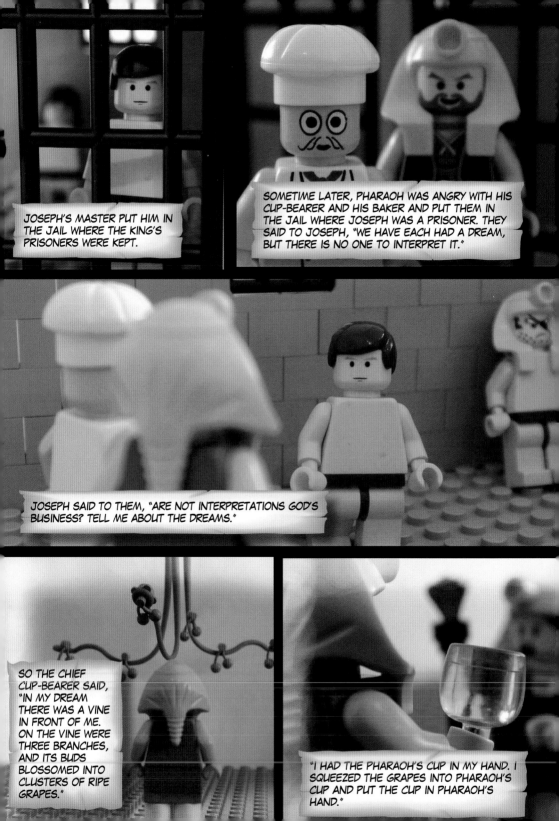

JOSEPH'S MASTER PUT HIM IN THE JAIL WHERE THE KING'S PRISONERS WERE KEPT.

SOMETIME LATER, PHARAOH WAS ANGRY WITH HIS CUP-BEARER AND HIS BAKER AND PUT THEM IN THE JAIL WHERE JOSEPH WAS A PRISONER. THEY SAID TO JOSEPH, "WE HAVE EACH HAD A DREAM, BUT THERE IS NO ONE TO INTERPRET IT."

JOSEPH SAID TO THEM, "ARE NOT INTERPRETATIONS GOD'S BUSINESS? TELL ME ABOUT THE DREAMS."

SO THE CHIEF CUP-BEARER SAID, "IN MY DREAM THERE WAS A VINE IN FRONT OF ME. ON THE VINE WERE THREE BRANCHES, AND ITS BUDS BLOSSOMED INTO CLUSTERS OF RIPE GRAPES."

"I HAD THE PHARAOH'S CUP IN MY HAND. I SQUEEZED THE GRAPES INTO PHARAOH'S CUP AND PUT THE CUP IN PHARAOH'S HAND."

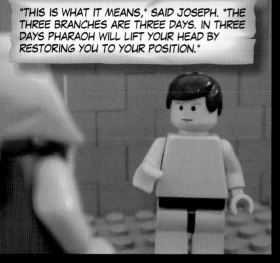

"THIS IS WHAT IT MEANS," SAID JOSEPH. "THE THREE BRANCHES ARE THREE DAYS. IN THREE DAYS PHARAOH WILL LIFT YOUR HEAD BY RESTORING YOU TO YOUR POSITION."

SEEING THAT THE INTERPRETATION HAD BEEN FAVORABLE, THE CHIEF BAKER SAID TO JOSEPH, "I, TOO, HAD A DREAM."

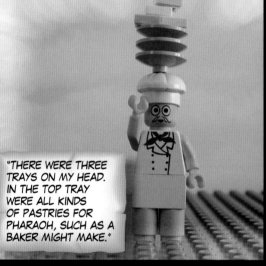

"THERE WERE THREE TRAYS ON MY HEAD. IN THE TOP TRAY WERE ALL KINDS OF PASTRIES FOR PHARAOH, SUCH AS A BAKER MIGHT MAKE."

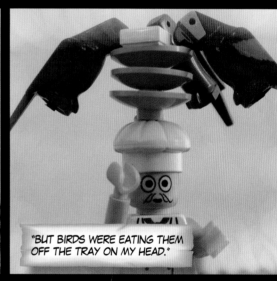

"BUT BIRDS WERE EATING THEM OFF THE TRAY ON MY HEAD."

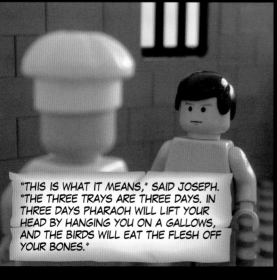

"THIS IS WHAT IT MEANS," SAID JOSEPH. "THE THREE TRAYS ARE THREE DAYS. IN THREE DAYS PHARAOH WILL LIFT YOUR HEAD BY HANGING YOU ON A GALLOWS, AND THE BIRDS WILL EAT THE FLESH OFF YOUR BONES."

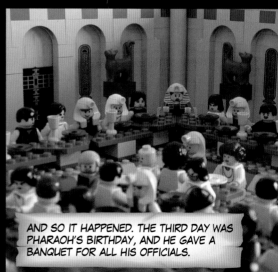

AND SO IT HAPPENED. THE THIRD DAY WAS PHARAOH'S BIRTHDAY, AND HE GAVE A BANQUET FOR ALL HIS OFFICIALS.

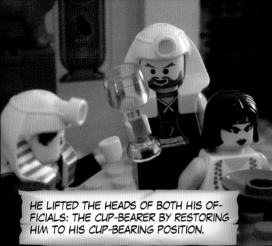

HE LIFTED THE HEADS OF BOTH HIS OFFICIALS: THE CUP-BEARER BY RESTORING HIM TO HIS CUP-BEARING POSITION.

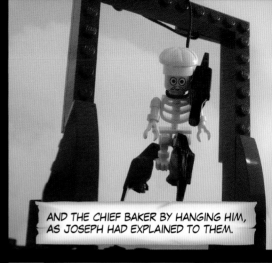

AND THE CHIEF BAKER BY HANGING HIM, AS JOSEPH HAD EXPLAINED TO THEM.

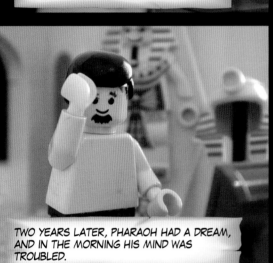

TWO YEARS LATER, PHARAOH HAD A DREAM, AND IN THE MORNING HIS MIND WAS TROUBLED.

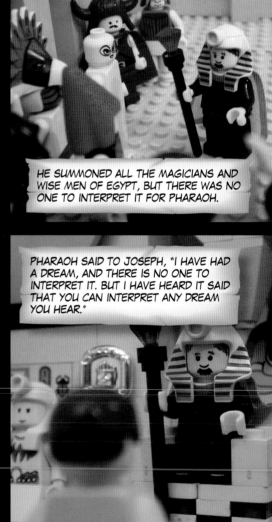

HE SUMMONED ALL THE MAGICIANS AND WISE MEN OF EGYPT, BUT THERE WAS NO ONE TO INTERPRET IT FOR PHARAOH.

PHARAOH SAID TO JOSEPH, "I HAVE HAD A DREAM, AND THERE IS NO ONE TO INTERPRET IT. BUT I HAVE HEARD IT SAID THAT YOU CAN INTERPRET ANY DREAM YOU HEAR."

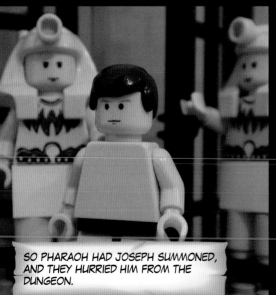

SO PHARAOH HAD JOSEPH SUMMONED, AND THEY HURRIED HIM FROM THE DUNGEON.

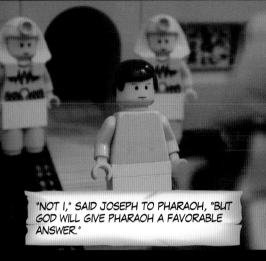

"NOT I," SAID JOSEPH TO PHARAOH, "BUT GOD WILL GIVE PHARAOH A FAVORABLE ANSWER."

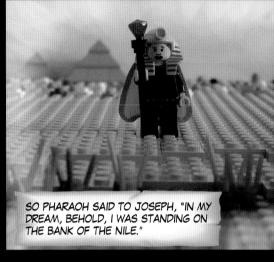

SO PHARAOH SAID TO JOSEPH, "IN MY DREAM, BEHOLD, I WAS STANDING ON THE BANK OF THE NILE."

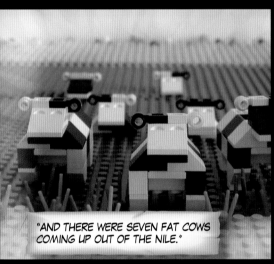

"AND THERE WERE SEVEN FAT COWS COMING UP OUT OF THE NILE."

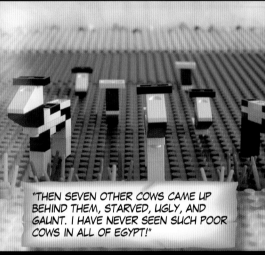

"THEN SEVEN OTHER COWS CAME UP BEHIND THEM, STARVED, UGLY, AND GAUNT. I HAVE NEVER SEEN SUCH POOR COWS IN ALL OF EGYPT!"

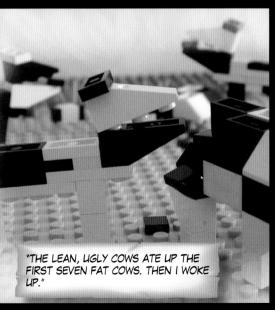

"THE LEAN, UGLY COWS ATE UP THE FIRST SEVEN FAT COWS. THEN I WOKE UP."

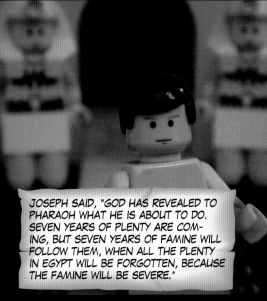

JOSEPH SAID, "GOD HAS REVEALED TO PHARAOH WHAT HE IS ABOUT TO DO. SEVEN YEARS OF PLENTY ARE COMING, BUT SEVEN YEARS OF FAMINE WILL FOLLOW THEM, WHEN ALL THE PLENTY IN EGYPT WILL BE FORGOTTEN, BECAUSE THE FAMINE WILL BE SEVERE."

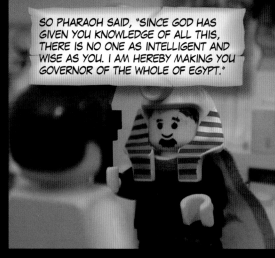

"PHARAOH SHOULD FIND A WISE, INTELLIGENT MAN TO GOVERN EGYPT AND STORE ALL THE EXTRA FOOD PRODUCED DURING THE SEVEN YEARS OF PLENTY, SO THAT THE COUNTRY WILL NOT BE DESTROYED BY THE SEVEN YEARS OF FAMINE."

SO PHARAOH SAID, "SINCE GOD HAS GIVEN YOU KNOWLEDGE OF ALL THIS, THERE IS NO ONE AS INTELLIGENT AND WISE AS YOU. I AM HEREBY MAKING YOU GOVERNOR OF THE WHOLE OF EGYPT."

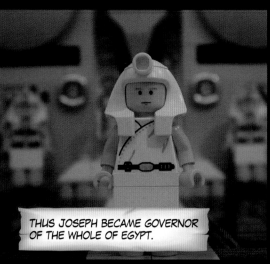

THUS JOSEPH BECAME GOVERNOR OF THE WHOLE OF EGYPT.

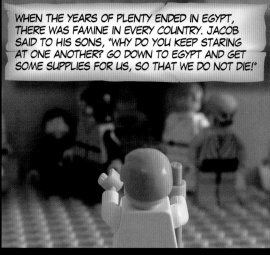

WHEN THE YEARS OF PLENTY ENDED IN EGYPT, THERE WAS FAMINE IN EVERY COUNTRY. JACOB SAID TO HIS SONS, "WHY DO YOU KEEP STARING AT ONE ANOTHER? GO DOWN TO EGYPT AND GET SOME SUPPLIES FOR US, SO THAT WE DO NOT DIE!"

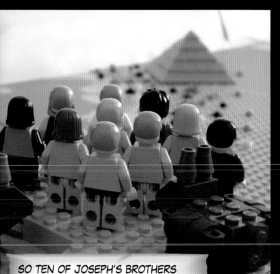

SO TEN OF JOSEPH'S BROTHERS WENT DOWN TO BUY GRAIN IN EGYPT.

BUT JACOB DID NOT SEND JOSEPH'S BROTHER BENJAMIN WITH HIS BROTHERS, FOR HE WORRIED THAT SOMETHING MIGHT HAPPEN TO HIM.

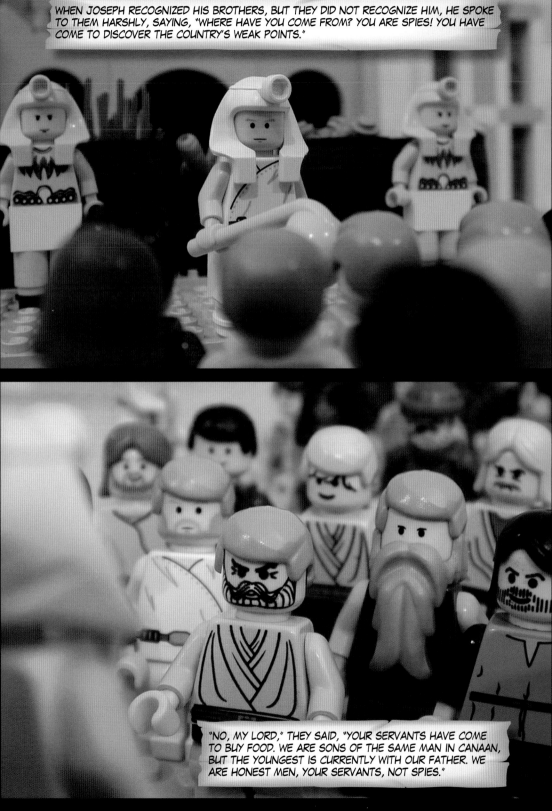

WHEN JOSEPH RECOGNIZED HIS BROTHERS, BUT THEY DID NOT RECOGNIZE HIM, HE SPOKE TO THEM HARSHLY, SAYING, "WHERE HAVE YOU COME FROM? YOU ARE SPIES! YOU HAVE COME TO DISCOVER THE COUNTRY'S WEAK POINTS."

"NO, MY LORD," THEY SAID, "YOUR SERVANTS HAVE COME TO BUY FOOD. WE ARE SONS OF THE SAME MAN IN CANAAN, BUT THE YOUNGEST IS CURRENTLY WITH OUR FATHER. WE ARE HONEST MEN, YOUR SERVANTS, NOT SPIES."

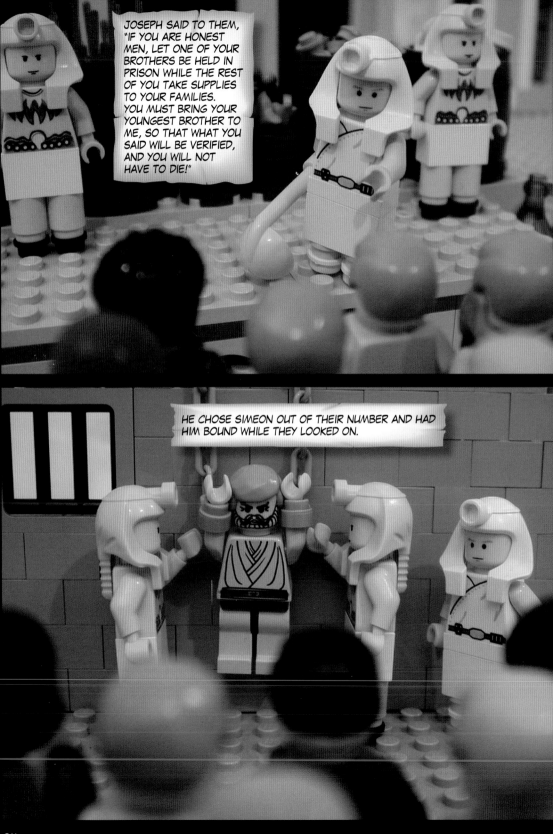

JOSEPH SAID TO THEM, "IF YOU ARE HONEST MEN, LET ONE OF YOUR BROTHERS BE HELD IN PRISON WHILE THE REST OF YOU TAKE SUPPLIES TO YOUR FAMILIES. YOU MUST BRING YOUR YOUNGEST BROTHER TO ME, SO THAT WHAT YOU SAID WILL BE VERIFIED, AND YOU WILL NOT HAVE TO DIE!"

HE CHOSE SIMEON OUT OF THEIR NUMBER AND HAD HIM BOUND WHILE THEY LOOKED ON.

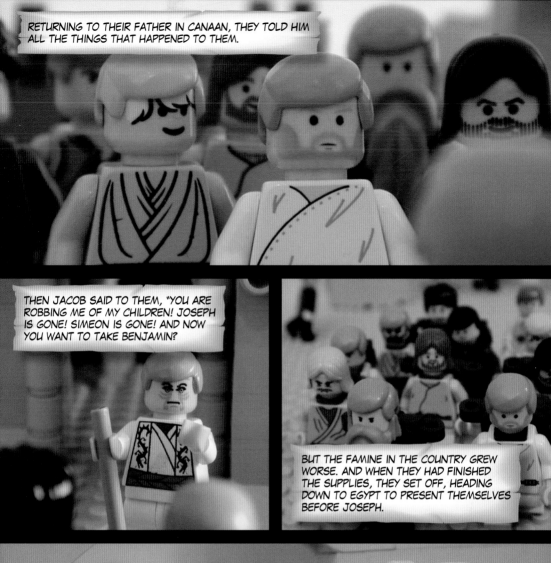

RETURNING TO THEIR FATHER IN CANAAN, THEY TOLD HIM ALL THE THINGS THAT HAPPENED TO THEM.

THEN JACOB SAID TO THEM, "YOU ARE ROBBING ME OF MY CHILDREN! JOSEPH IS GONE! SIMEON IS GONE! AND NOW YOU WANT TO TAKE BENJAMIN?

BUT THE FAMINE IN THE COUNTRY GREW WORSE. AND WHEN THEY HAD FINISHED THE SUPPLIES, THEY SET OFF, HEADING DOWN TO EGYPT TO PRESENT THEMSELVES BEFORE JOSEPH.

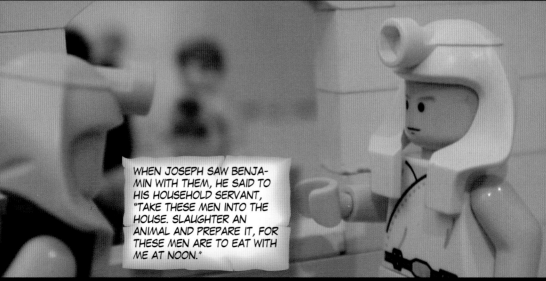

WHEN JOSEPH SAW BENJA-MIN WITH THEM, HE SAID TO HIS HOUSEHOLD SERVANT, "TAKE THESE MEN INTO THE HOUSE. SLAUGHTER AN ANIMAL AND PREPARE IT, FOR THESE MEN ARE TO EAT WITH ME AT NOON."

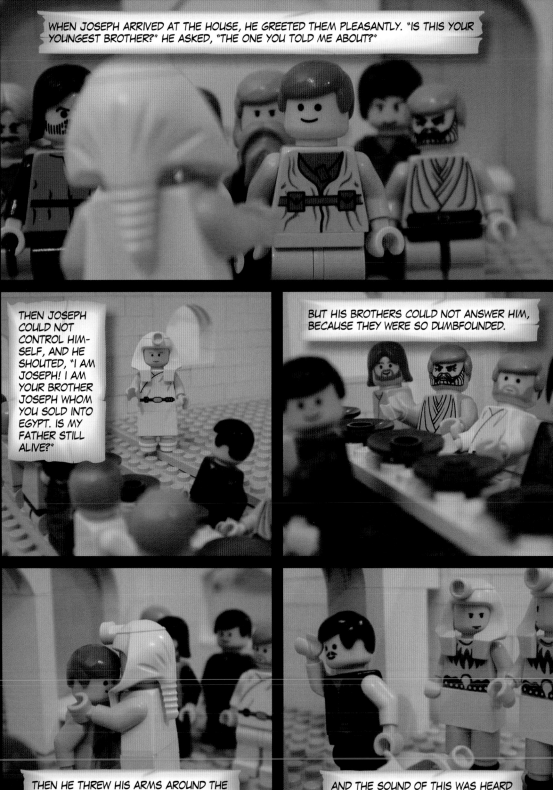

WHEN JOSEPH ARRIVED AT THE HOUSE, HE GREETED THEM PLEASANTLY. "IS THIS YOUR YOUNGEST BROTHER?" HE ASKED, "THE ONE YOU TOLD ME ABOUT?"

THEN JOSEPH COULD NOT CONTROL HIM- SELF, AND HE SHOUTED, "I AM JOSEPH! I AM YOUR BROTHER JOSEPH WHOM YOU SOLD INTO EGYPT. IS MY FATHER STILL ALIVE?"

BUT HIS BROTHERS COULD NOT ANSWER HIM, BECAUSE THEY WERE SO DUMBFOUNDED.

THEN HE THREW HIS ARMS AROUND THE NECK OF BENJAMIN, AND HE WEPT.

AND THE SOUND OF THIS WAS HEARD IN THE HOUSE OF PHARAOH.

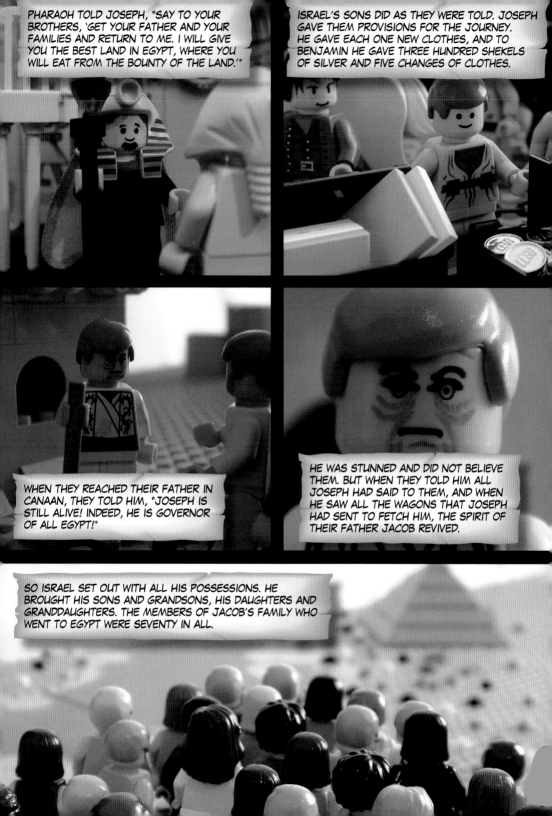

PHARAOH TOLD JOSEPH, "SAY TO YOUR BROTHERS, 'GET YOUR FATHER AND YOUR FAMILIES AND RETURN TO ME. I WILL GIVE YOU THE BEST LAND IN EGYPT, WHERE YOU WILL EAT FROM THE BOUNTY OF THE LAND.'"

ISRAEL'S SONS DID AS THEY WERE TOLD. JOSEPH GAVE THEM PROVISIONS FOR THE JOURNEY. HE GAVE EACH ONE NEW CLOTHES, AND TO BENJAMIN HE GAVE THREE HUNDRED SHEKELS OF SILVER AND FIVE CHANGES OF CLOTHES.

WHEN THEY REACHED THEIR FATHER IN CANAAN, THEY TOLD HIM, "JOSEPH IS STILL ALIVE! INDEED, HE IS GOVERNOR OF ALL EGYPT!"

HE WAS STUNNED AND DID NOT BELIEVE THEM. BUT WHEN THEY TOLD HIM ALL JOSEPH HAD SAID TO THEM, AND WHEN HE SAW ALL THE WAGONS THAT JOSEPH HAD SENT TO FETCH HIM, THE SPIRIT OF THEIR FATHER JACOB REVIVED.

SO ISRAEL SET OUT WITH ALL HIS POSSESSIONS. HE BROUGHT HIS SONS AND GRANDSONS, HIS DAUGHTERS AND GRANDDAUGHTERS. THE MEMBERS OF JACOB'S FAMILY WHO WENT TO EGYPT WERE SEVENTY IN ALL.

WHEN THEY ARRIVED IN GOSHEN, JOSEPH WENT TO MEET HIS FATHER ISRAEL. AS SOON AS HE APPEARED, HE THREW HIS ARMS AROUND HIS NECK AND WEPT ON HIS SHOULDER FOR A LONG TIME.

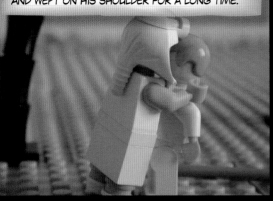

JOSEPH BROUGHT HIS FATHER AND PRESENTED HIM TO PHARAOH. PHARAOH ASKED JACOB, "HOW MANY YEARS HAVE YOU LIVED?"

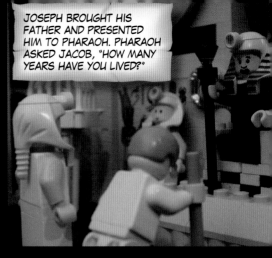

JACOB SAID TO PHARAOH, "THE YEARS OF MY JOURNEY ON EARTH HAVE BEEN 130 YEARS. FEW AND UNHAPPY MY YEARS HAVE BEEN, FALLING SHORT OF MY ANCESTORS' YEARS IN THEIR JOURNEYS ON EARTH."

JACOB THEN TOOK LEAVE OF PHARAOH, WITHDRAWING FROM HIS PRESENCE.

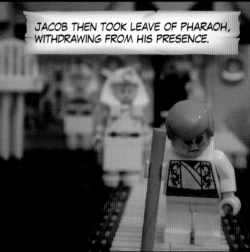

WHEN ISRAEL'S TIME TO DIE DREW NEAR HE SENT FOR HIS SON JOSEPH AND SAID TO HIM, "IF YOU LOVE ME, PLACE YOUR HAND UNDER MY THIGH AS AN OATH THAT YOU WILL ACT WITH FAITHFUL LOYALTY TO ME: DO NOT BURY ME IN EGYPT!"

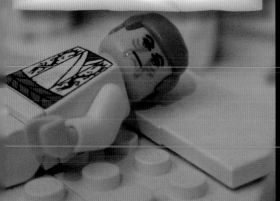

SO HE SWORE TO HIM, AND ISRAEL SANK BACK ON THE PILLOW. HE DREW HIS FEET UP INTO BED, AND BREATHING HIS LAST, JACOB WAS GATHERED TO HIS ANCESTORS. AT THIS JOSEPH THREW HIMSELF ON HIS FATHER'S FACE, COVERING IT WITH TEARS AND KISSES.

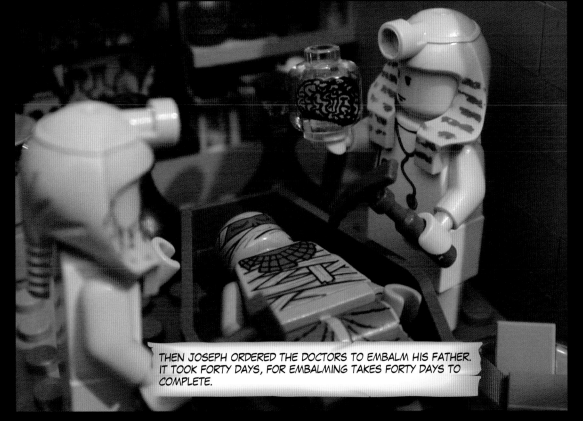

THEN JOSEPH ORDERED THE DOCTORS TO EMBALM HIS FATHER. IT TOOK FORTY DAYS, FOR EMBALMING TAKES FORTY DAYS TO COMPLETE.

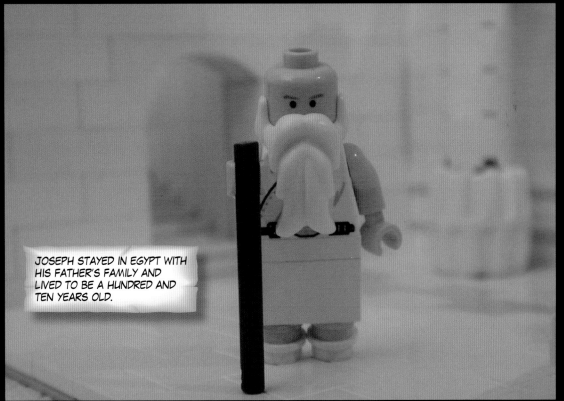

JOSEPH STAYED IN EGYPT WITH HIS FATHER'S FAMILY AND LIVED TO BE A HUNDRED AND TEN YEARS OLD.

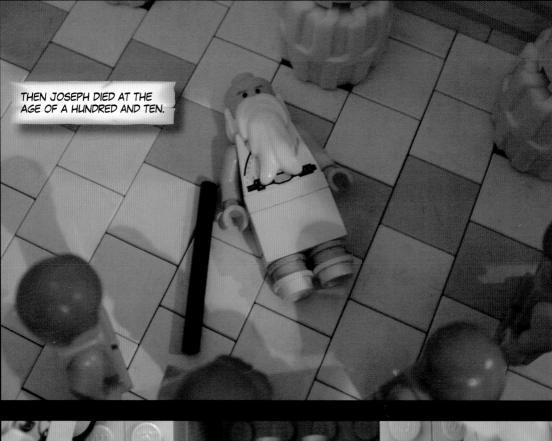

THEN JOSEPH DIED AT THE AGE OF A HUNDRED AND TEN.

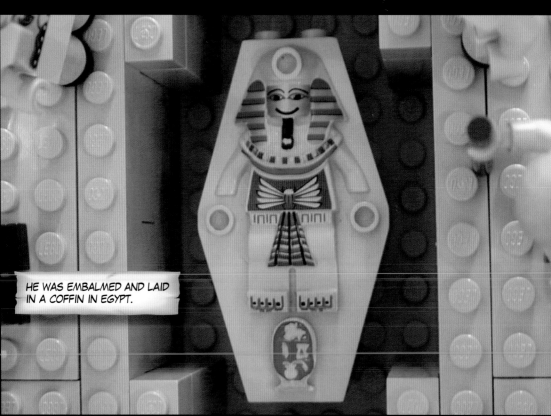

HE WAS EMBALMED AND LAID IN A COFFIN IN EGYPT.

THE STORY OF THE ISRAELITES CONTINUES WITH MOSES, THE BURNING BUSH, THE TEN PLAGUES, THE PARTING OF THE RED SEA, THE GOLDEN CALF, THE TEN COMMANDMENTS, MANNA FROM HEAVEN, AND THE ARK OF THE COVENANT IN . . .